Focus On Apple Aperture

The *Focus On* Series

Photography is all about the end result – your photo. The *Focus On* series offers books with essential information so you can get the best photos without spending thousands of hours learning techniques or software skills. Each book focuses on a specific area of knowledge within photography, cutting through the often confusing waffle of photographic jargon to focus solely on showing you what you need to do to capture beautiful and dynamic shots every time you pick up your camera.

Titles in the *Focus On* series:

Focus On
Apple Aperture

Corey Hilz

AMSTERDAM • BOSTON • HEIDELBERG • LONDON • NEW YORK • OXFORD • PARIS
SAN DIEGO • SAN FRANCISCO • SINGAPORE • SYDNEY • TOKYO

Focal Press is an imprint of Elsevier

Focal Press is an imprint of Elsevier
225 Wyman Street, Waltham, MA 02451, USA
The Boulevard, Langford Lane, Kidlington, Oxford, OX5 1GB, UK

Notices

Knowledge and best practice in this field are constantly changing. As new research and experience broaden our understanding, changes in research methods, professional practices, or medical treatment may become necessary.

Practitioners and researchers must always rely on their own experience and knowledge in evaluating and using any information, methods, compounds, or experiments described herein. In using such information or methods they should be mindful of their own safety and the safety of others, including parties for whom they have a professional responsibility.

To the fullest extent of the law, neither the Publisher nor the authors, contributors, or editors, assume any liability for any injury and/or damage to persons or property as a matter of products liability, negligence or otherwise, or from any use or operation of any methods, products, instructions, or ideas contained in the material herein.

Library of Congress Cataloging-in-Publication Data
Application submitted.

British Library Cataloguing-in-Publication Data
A catalogue record for this book is available from the British Library.

ISBN: 978-0-240-81513-8

For information on all Focal Press publications
visit our website at *www.elsevierdirect.com*

11 12 13 14 15 5 4 3 2 1

Printed in China

Typeset by: diacriTech, Chennai, India

About the Author

Corey Hilz is a professional photographer specializing in nature and travel photography. His work is seen in magazines, books, calendars, and catalogues, as well as in art galleries. Corey finds that diversity in nature offers boundless opportunities for new images. He approaches his subjects with an artistic eye, looking for a fresh perspective. Corey has a passion for helping others improve their photography by sharing his knowledge through group and private instruction. He leads workshops to locations in the United States and abroad. See more of Corey's photography on his website: coreyhilz.com.

Contents

Introduction

ORGANIZING AND EDITING are key parts to the process of digital photography. However, we don't want to spend an exhaustive amount of time working with our photos on the computer. When we capture hundreds or thousands of photographs, having a streamlined workflow to process them is important. If you're like me, you don't want to spend more time on the computer than you have to. Being efficient with your time will allow you to get the most out of your photos in the least amount of time. This book will take you step by step through a workflow using Apple Aperture to organize, edit, and selectively adjust your photographs – plus you can use Aperture to share your photos. We won't examine every feature of the application but instead will focus on those that are the most useful, making your tasks of editing and organizing easier.

Chapter 1: Importing

WHAT BETTER PLACE to start than at the beginning of the entire workflow. In this chapter we'll walk through the importing process. The idea of downloading photos off your memory card is pretty straightforward, but it's not just about inserting your memory card and clicking Import. Aperture offers a lot of options during the importing stage. Some of these options can save you time; others are just good steps in an efficient workflow. Even if you're already familiar with importing photos, take the time to read

through this chapter because you might pick up a tidbit you didn't know!

To begin the importing process, insert a memory card into a card reader or connect a camera to your computer and turn on the camera. If Aperture is already open when you do this, it will recognize the memory card (or camera) now connected and will pop open the importing options. If this doesn't happen automatically, click the Import button in the toolbar or press Command-I.

In the top left of the Aperture window, you choose the importing source. Whatever is highlighted in dark gray is the source; Aperture chooses a memory card or camera by default.

You can also import photos that are already on your computer. To do this, click on the name of your computer; then at the bottom of the window, navigate to the folder that has the photos you want to import.

Choosing files to import

By default, all the photos shown in the import window will be imported. If you don't want to import certain images, click their checkboxes to uncheck them.

You can check or uncheck all the files using the buttons at the top of the import window.

Import settings

No matter the location of the photos you're importing, you have the same set of Import Settings found along the right side of the Aperture window. The Import Settings are broken into ten groups: File Info, Aperture Library, Rename Files, Time Zone, Metadata Presets, Adjustment Presets, File Types, RAW+JPEG Pairs, Actions, and Backup Location.

Double-click a thumbnail to bring it up full screen; double-click again to go back to the thumbnail view.

You can control which settings you see by clicking the Import Settings button (located at the top of the list of Import Settings). The settings with checkmarks next to them are visible; no checkmark means the setting is hidden. Click a setting name to check or uncheck it.

Now let's look at the options for each of the Import Settings.

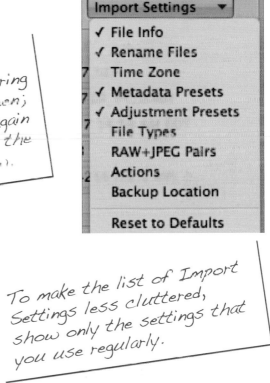

To make the list of Import Settings less cluttered, show only the settings that you use regularly.

File info

The File Info group shows information about a selected file. The Version Name is what the file will be named in the Aperture Library. This is controlled by the Rename Files option, which is one of the Import Settings.

Aperture library

Destination: Choose the project where you want the photos to go. Click on the project name displayed to bring up a list of recent projects and the option to create a new project. You can also change the destination by clicking on a different project in the Library panel.

Store Files: Choose to keep files in the Aperture Library (managed files) or in a folder on your computer (referenced files). See the next section, "Managed Files versus Referenced Files,"

File Info

File Name:	_DSC5325.NEF
Version Name:	Hilz_100710_5583.NEF
File Date:	7/10/10 9:08:57 AM EDT
Size:	13.05 MB
Dimensions:	2832 × 4256 (12.1 MP)
Attachment:	None

for more detailed information about these options.

Subfolder: This option is available only when your photos are referenced files. Click the Subfolder option to show a pop-up menu with naming options for the subfolder or choose Edit to customize the folder name.

Aperture Library

Destination: ⬚ Initial Edit ⬍

☐ Automatically split projects
☑ Do not import duplicates

Store Files: initial download ⬍

Subfolder: None ⬍

Keep the Do not import duplicates box checked; this setting hides any previously imported photos on your memory card.

The Automatically split projects option is available only if you choose New Project for the Destination. How photos are split into projects is controlled in the Preferences (Aperture > Preferences). Go to the Import section where you'll see the choices for Autosplit into Projects.

Managed files versus referenced files

All the information about your photos (ratings, previews, adjustments, metadata, photo organization) is stored in the Aperture Library. Think of your Aperture Library as a giant folder that holds all this information. However, for your actual photos, you have a choice whether you want them also stored in the Aperture Library or to be located elsewhere on your hard drive. When you're importing, the Store Files option in the Aperture Library section is the place where you choose the location for your photos. Here, you can select In the Aperture Library or Choose (which means picking a folder on your hard drive). This is an important decision to make upon import. Read about the differences below and then decide which you prefer and stick with it for all your importing.

Managed Files: Photos are stored in the Aperture Library. A good point about this system is that when you use the Vault feature to back up your library,

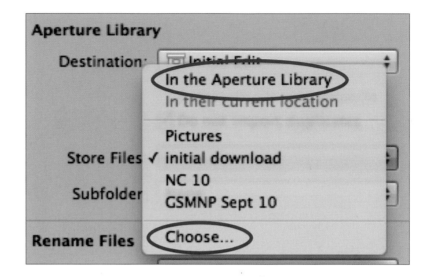

you'll be backing up your photos and all their settings. However, if you have thousands or tens of thousands of photos, your Aperture Library file can become enormous (hundreds of gigabytes) because the photos take up so much space. For this reason, I don't use the Managed Files system.

Referenced files: Photos are **not** stored in the library. You choose where to save them on an internal or external hard drive. Using Referenced

Files helps keep your Aperture Library from becoming too large. It's important to know that the Vault doesn't back up referenced photos, only the settings for the photos. The Vault is covered in more detail in Chapter 3. With Referenced Files, you'll need another method, such as Time Machine, to back up your actual photos (which is just as important as backing up the settings for the photos).

You have the option to back up your photos when you import them, which is a good first step. I recommend you also have a way to update those backup photos. Let's say you import (and back up) 300 photos, but after editing you decide to keep only 50 of the 300. If you don't update the backup of your photos, you still have the full 300 photos in the backup. No need to keep those extra 250 photos on your backup hard drive.

Rename files

Rename Files allows you to rename photos as they are imported. Version Name refers to the name of the photo when you see it in Aperture. Renaming files is a good practice; that way, you avoid ending up with two photos that have the same filename in the future. Your camera will eventually cycle back and use the same file numbers again, so renaming avoids any confusion that could create. Click the Version Name option to choose one of the standard presets or select Edit to customize the naming. See Chapter 6 for information on creating file naming presets.

Rename Files

Version Name: Standard Naming

☑ Rename Master File

Check Rename Master File so that the photo on your computer has the same name as what you see in the Aperture Library.

Time zone

If you take a trip and photograph in a different time zone, the Time Zone setting makes it easy to correct the time stamp for when the photo was taken. When I was photographing in Ireland, the Camera Time was America/New York, and I set the Actual Time to Europe/Dublin. Now all my photos have the correct local time.

Time Zone

Camera Time: America/New York

Actual Time: Europe/Dublin

Metadata presets

Metadata presets allow you to use a preset to add metadata to your photos on import. From the Metadata pop-up menu, choose the preset name or select Edit to create or modify a preset. Select the button for Replace. See Chapter 6 for information on creating metadata presets. Keep in mind that whatever metadata you choose to add needs to apply to all the photos you're importing. For instance, if you are using a preset with location information, all the photos to be imported need to be from that same location. Otherwise, you're just making more work for yourself when you have to remove metadata from individual photos. Information that would be safe to add to any photo is your contact information (name, email, address, phone, website, copyright notice).

Metadata Presets

Metadata: Blackwater Falls SP WV

○ Append ● Replace

☑ Image Location: Blackwater Falls State Park

☑ Image City: Davis

☑ State/Province: West Virginia

☑ Image Country: United States

Adjustment presets

The Adjustment Presets settings provide a convenient way to apply specific adjustments when the photos are being imported. If you have certain adjustments you regularly apply to all your photos, you can use a preset to have Aperture take care of it right now. From the Preset pop-up menu, choose the preset name. See Chapter 5 for information on creating adjustment presets.

I have found a certain combination of Contrast, Saturation, and Vibrancy that works well for most of my nature and travel photography. This gives me a good starting point for additional adjustments so I don't begin looking at a flat, dull RAW file. Here's the combo I use: Contrast: 0.05, Saturation: 1.05, Vibrancy: 0.10.

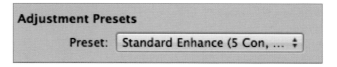

Adjustment Presets

Preset: Standard Enhance (5 Con, ...

File types

The checkboxes in the File Types section allow you to exclude certain file types. Check the box for what you don't want to import, and those thumbnails will disappear from the import window.

File Types

☐ Exclude photos

☐ Exclude videos

☐ Exclude audio files

☐ Exclude audio attachments

☐ Only include files flagged/locked in camera

RAW+JPEG pairs

If your camera is set to capture both RAW and JPEG files, you can use the RAW+JPEG Pairs setting to choose whether you want both files imported or just one or the other.

Even if you import both, the import option you choose makes a big difference in how you can work with the RAW and JPEG files. If you use either of the first two choices, you will see only one photo in your library (whichever is chosen as Master) even though there is both a RAW and a JPEG for that image. This makes it seem as though there's only one file there, but there are actually two. Any adjustments you make to the photo will be applied to both the RAW and JPEG files. You can change which is the Master (RAW or JPEG) after importing by going to Photos>Set RAW/JPEG as Master.

If you choose Both (Separate Masters), then you'll see both the RAW and the JPEG Masters in your library. They'll be independent files, and you can apply different adjustments to them.

If you previously just imported JPEGs, you can import again and choose Matching RAW files to import just the RAW files that match the JPEGs already in your library.

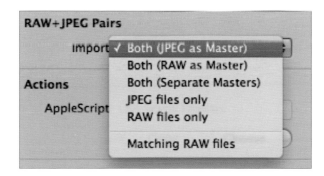

RAW+JPEG Pairs

Import ✓ Both (JPEG as Master)
 Both (RAW as Master)
Actions Both (Separate Masters)
 JPEG files only
AppleScript RAW files only

 Matching RAW files

Actions

If there is an AppleScript you want to use during import, you can select it under Actions.

Backup location

It's important to have a backup system for your photographs. Because there are no negatives to go back to with digital photos, having at least one backup copy of all your photographs is essential. If you have only one copy and something happens to your hard drive, your photos will be lost. The Backup Location option gives you a quick and easy way to make sure your photos are backed up from the moment you import them. You can also choose a Subfolder naming preset.

The Backup Location should be on a different hard drive from what you selected for Store Files in the Aperture Library section earlier. External hard drives are great for this. Placing your backup on the same hard drive doesn't do you any good. If you don't already have a backup system in place, using the Backup Location option is a convenient way to make sure you have that all-important backup.

Actions

AppleScript: No Script Selected

Clear Choose...

Backup Location

Backup To: WD 500GB

Subfolder: None

Begin import

After you've set all your import options, click the Import Checked button at the bottom of the window.

To see the progress of the importing and processing of the images, bring up the Activity window by going to Window>Show Activity (or press Shift-Command-zero).

After importing is complete, you'll see the Import Complete dialog box. Unless you need to do something else with the memory card, go ahead and click Eject Card. I don't recommend having Aperture erase the card; instead, use your camera to format the card.

Activity

Activity	Description	Status
▼ Import		1
▼ Import	Importing 178 items into project Initial Edit	Completing
Copying Files	Copying files to /Volumes/WD 1TB/Drop Folc	165 of 178
▼ Updating Library		1
Processing	Processing	Queued

Pause Task Cancel Task ☐ Hide Queued Tasks

Import Complete

178 items have been imported from "NIKON D700" into the project named "Initial Edit".

☐ Do not show this message again

(Done) (Erase and Eject Card) (Eject Card)

Conclusion

Now with a set of images imported into Aperture, you can turn your attention to viewing and organizing them. In the next two chapters, you'll become familiar with Aperture's layout, organizational features, and backup option. You'll learn what information about your images is available, the various ways you can view your photos, and how to set up an organizational structure that makes it easy to keep track of your photographs.

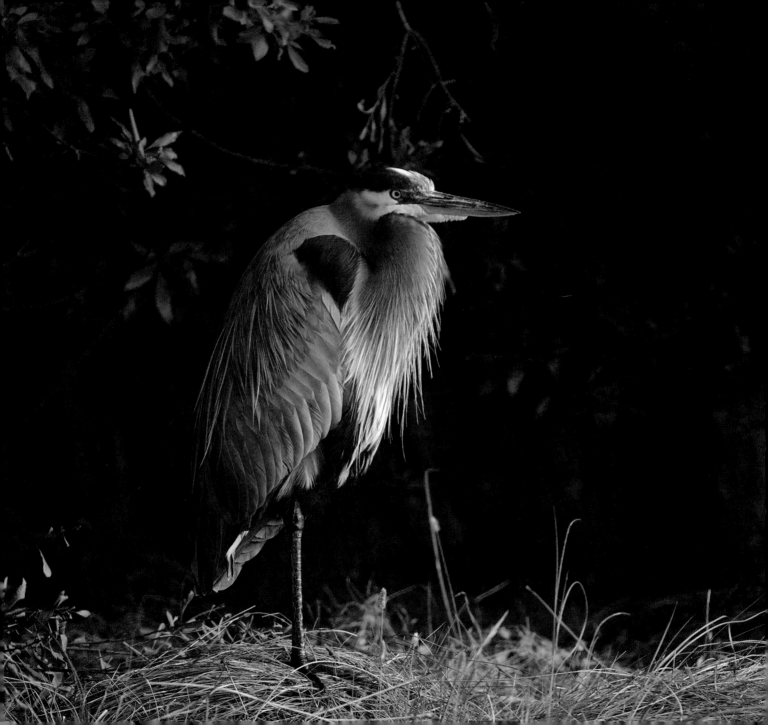

Chapter 2: Layout and Viewing Images

IN THIS CHAPTER we'll take a tour of Aperture's layout. You'll become familiar with the contents of the Inspector's three panels and the toolbar. Then we'll explore the viewing options for photos. These options include displaying photos one at a time, displaying them as thumbnails, or a combination of the two. There's also a slick full screen mode. You'll even find out how you can customize the technical data shown alongside images, a convenient quick reference feature. By the end of the chapter, you'll be navigating the Aperture interface with ease.

Toolbar

The toolbar is displayed across the top of the Aperture window. It offers button access to various commands, views, and tools. There are a lot more choices for what you can have in the toolbar than what is shown by default.

To customize the toolbar, go to View>Customize Toolbar to add or delete items.

Show/Hide the Toolbar

Keyboard Shortcut: Shift-T

Menu: View>Hide/Show Toolbar

On-screen: Click the oval button in the top-right corner of the Aperture window.

Inspector

The Inspector holds the Library, Metadata, and Adjustments panels. Cycle through the three panels by pressing W. You can also show or hide the Inspector by pressing I. We'll look at an overview of each panel and then cover the features of each one in depth in a later chapter. Chapter 3 has details on the Library panel's organizational features. The Metadata panel is explored in Chapter 6. Chapters 4 and 5 focus on the Adjustments panel.

The Inspector can be on the left or right side of your monitor. To change its location, go to View > Inspector > Swap Position.

Library panel

The Library panel is the place where everything is stored. There are four key tools you can use in the Library panel to help you organize your photos: projects, folders, albums, and smart albums. Other items that can also be located in the Library panel are books, light tables, slideshows, web journals, web pages, and smart web pages; however, these are tools for output, not organizing photos.

Library Group

Aperture automatically creates this group at the top of the Library panel. Here's what's inside:

Projects

Choosing Projects shows all projects. Each project is represented by a square thumbnail along with the project name. The thumbnail, called the *key photo*, is a square, cropped version of one of the photos in the project. If you drag your mouse pointer across the thumbnail, the thumbnail will change to cycle through the photos in the project.

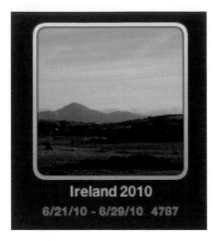

Ireland 2010
6/21/10 - 6/29/10 4787

For the selected project (outlined in yellow) or any project you move the mouse pointer to, Aperture shows the date range the photos cover and how many photos are in the project.

While you're in the info window for a project, if you see a photo you want to work on while scanning through the photos, double-click it and Aperture will take you to that project and select the photo.

THE KEY PHOTO

The key photo is the main one shown for the project. To choose a different key photo, scan through the images with your cursor. When you find the photo you want, press the spacebar.

You can also set the key photo for a project while regularly editing photos. Select a photo; then go to Photos>Set Key Photo for Project OR right-click (Control-click) on the photo and choose Set Key Photo. The photo you selected will then be the cover for the project the next time you go to the All Projects view.

Also, for the selected project or any one you point the mouse to, an "i" appears in the bottom right corner. Click the "i" to bring up an info box for the project.

Here, you can change the name, enter a description, and assign a location. You can also set the key photo by moving the mouse pointer across the thumbnail to

scan the photos and then clicking the one you want. Use the arrows at the bottom to move to the previous or next project.

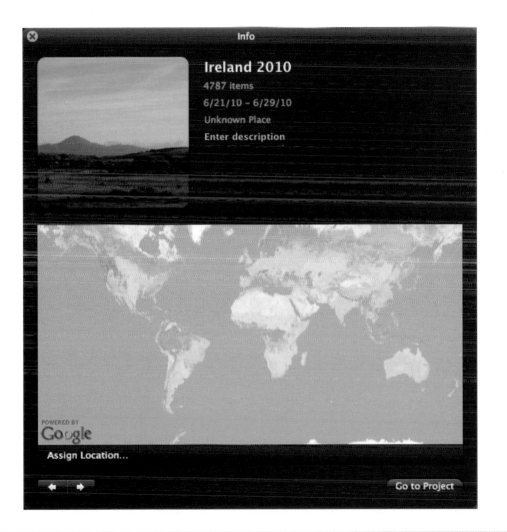

Photos

Choosing Photos shows all the photos in your Library. Standard viewing options apply: Browser, Split View, Viewer (these options are described later in this chapter).

Faces

Choosing Faces switches to the Faces display.

Double-click on a face to show all the thumbnails for photos with that person. If you drag your mouse pointer across the face thumbnail, the thumbnail will change to cycle through all the photos of that person. For whichever face you move the mouse pointer to, Aperture shows how many photos there are of that person (bottom left).

For any face you point the mouse to, an "i" appears in the bottom-right corner. Click the "i" to bring up an info box for the project.

Here, you can change the name, enter a full name (if, for instance, you're just using the first name in the main Faces display), and

include an email address. Use the arrows at the bottom to move to the previous or next person.

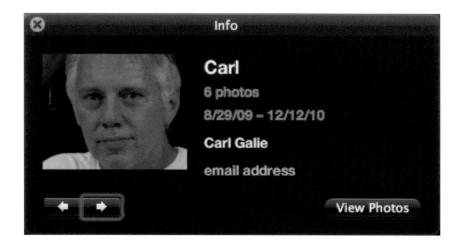

Accessing the Faces Display
Keyboard Shortcut: Shift-F
On-screen: Click the Faces
button in the toolbar or
click Faces in the Library
panel.
Menu: View>Faces

Places

Choosing Places switches to the Places display. Photos in your library that have GPS information are represented by pins on the map.

Accessing the Places Display

Keyboard Shortcut: Shift-P

On-screen: Click the Places button in toolbar or click Places in the Library panel.

Menu: View>Places

Flagged

Choosing Flagged displays photos that have been tagged with a flag (the orange flap that appears in the upper-right corner of the thumbnail). See Chapter 4 for details about using flags.

Trash

Choosing Trash displays photos that have been moved to the trash. To empty the trash, go to Aperture>Empty Aperture Trash or press Shift-Command-Delete. You can find more information about using the Trash in Chapter 4.

Metadata panel

The Metadata panel shows you information about the selected photo. There are two main types of metadata: EXIF and IPTC.

EXIF data is technical info from your camera (aperture, shutter speed, ISO, and so on) that you can't change. IPTC is information you choose to add in Aperture.

Examples of IPTC info include your contact information, the location where the photo was taken, and keywords.

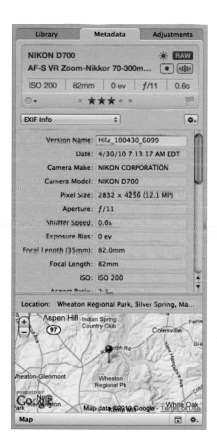

At the top of the panel is the basic exposure and equipment info for the selected photo.

Directly below this section is a pop-up menu where you can choose what grouping of EXIF and/or IPTC metadata you want to display below. Aperture comes with a number of preset groups; you can edit them as well as create your own.

At the bottom of the Metadata panel is the Map display, which is hidden by default. To show the map, click the icon that looks like a box with a triangle in it.

If the photo has GPS info or you assigned a location using the Places feature, there will be a pin marking where the photo was taken; otherwise, you'll see a blank map of the world.

Adjustments panel

The Adjustments panel contains the settings for enhancing your photographs. The various adjustments are broken down into what are called *bricks*. Each brick has a title with a checkbox next to it. Bricks are separated by a thin horizontal line. The default bricks are White Balance, Exposure, Enhance, Highlights & Shadows, Levels, and Color. A brick can contain one or more adjustments.

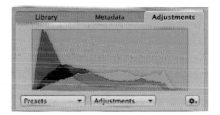

At the top of the Adjustment panel is the histogram for the selected photo as well as two pop-up menus: one for Adjustment presets and the other containing a list of all available adjustments.

Photo viewing modes

To the right of the Inspector is the photo viewing area. Three modes determine how you can view your photos: Browser, Viewer, and Split View.

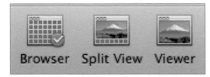

- **Browser:** A grid view where the photos are shown as thumbnails.

Change the Viewing Mode

Keyboard Shortcut: Press V to cycle through the three modes.

On-screen: Click the buttons in the toolbar for Browser, Split View, or Viewer.

To change the size of the thumbnails, use the slider in the bottom-right corner of the window.

- **Viewer:** View the selected photo only; the photo fills the viewing area.
- **Split view:** A combination of Browser and Viewer. The selected image is shown along with a thumbnail strip (see figure on next page). The thumbnail strip can be on any side of the selected image. To change its location, go to View>Browser; then choose Rotate Position or Swap Position. Rotate switches the thumbnail strip from a horizontal to a vertical position or vice versa. Swap changes which side of the image the thumbnails are located on.

To change the size of the thumbnails in Split View, place your mouse pointer on the line separating the single image from the thumbnail strip. The mouse pointer will change to a double-arrow. Click and drag toward the thumbnails to make them smaller or drag away from them to make them bigger. There is a limit to how big or small you can make them.

SCROLL THROUGH IMAGES

In the Split View or Viewer modes, you can use the up/down or left/right arrow keys to move through the thumbnails, changing which photo is selected. You can also scroll through images by placing your mouse pointer over the large image and turning the scroll wheel. If you're using a trackpad instead of a mouse, place two fingers on the trackpad and move them left/right or up/down to scroll. To enable this capability (on the mouse wheel or trackpad), you must have a particular option checked in Aperture's Preferences (Aperture>Preferences). Go to the General tab in Preferences and click the box for Scroll to navigate photos in the Viewer.

Whenever you have thumbnails visible (Browser, Split View), there are three ways to view them: Film Strip, Grid, and List. To change how they're displayed, click the thumbnail view buttons, located at the top of the thumbnail area.

- **Film strip:** Single strip of thumbnails
- **Grid:** Multiple strips of thumbnails
- **List:** Small thumbnails with version name and columns of other metadata

The List View is for looking at information, not photos. There are thumbnails shown, but the Size slider ranges from small to tiny.

Version Name	Keywords	Image Location	Image City	State/	Image	Creator	Creator's
Hilz_090524_9819		Oatlands Plantation	Leesburg	Virginia	United St...	Corey Hilz	Photogra.
Hilz_090524_9815		Oatlands Plantation	Leesburg	Virginia	United St...	Corey Hilz	Photogra.
Hilz_090524_9796p	panorama	Oatlands Plantation	Leesburg	Virginia	United St...	Corey Hilz	Photogra.
Hilz_090524_9783			Middleburg	Virginia	United St...	Corey Hilz	Photogra.
Hilz_090524_9775			Middleburg	Virginia	United St...	Corey Hilz	Photogra.
Hilz_090524_9768			Middleburg	Virginia	United St...	Corey Hilz	Photogra.
Hilz_090524_9762			Middleburg	Virginia	United St...	Corey Hilz	Photogra.
Hilz_090524_9753			Middleburg	Virginia	United St...	Corey Hilz	Photogra.
Hilz_090524_0021a			The Plains	Virginia	United St...	Corey Hilz	Photogra.
Hilz_090523_9695		Local Garden	Waterford	Virginia	United St...	Corey Hilz	Photogra.
Hilz_090523_9675		Local Garden	Waterford	Virginia	United St...	Corey Hilz	Photogra.
Hilz_090523_9572	LB Comp...		Waterford	Virginia	United St...	Corey Hilz	Photogra.
Hilz_090523_9547	LB Comp...		Waterford	Virginia	United St...	Corey Hilz	Photogra.
Hilz_090523_9533	LB Comp...		Waterford	Virginia	United St...	Corey Hilz	Photogra.

List view tips

- To rearrange the columns, click and drag the column names.

- Change the column width by placing your mouse pointer between the column names; then click and drag.

You can double-click a thumbnail to switch to Viewer mode (single image). Double-click it again to go back to the previous viewing mode (Browser or Split View).

DISPLAY TWO PROJECTS IN SEPARATE WINDOWS

Option-click a second project name to open a separate browser window for that project. You'll see two projects highlighted in the Library panel. You can have only two projects side by side. If you Option-click another project, it'll replace one of the projects currently shown.

View photos from multiple projects at once: Command-click project names to select multiple projects. The photos for all the selected projects will be shown together.

Zooming in

To get a closer view of the details in your photos, you can quickly zoom in to 100% (full size) by pressing the Z key (press Z again to zoom out). Aside from simply enabling you to see the fine details, the zoomed-in view makes it easier to work with certain tools and image adjustments.

With an image enlarged, you can see only part of it on your monitor, so it's important to know how to move the photo around to see different areas. How you go about doing this depends on whether you're using a tool. In this section I detail the different methods available so that throughout the book when I say to zoom in and move around the image, you know what your options are.

- **Method 1:** This method can always be used. When you're zoomed in, you'll see a dark gray box labeled 100% on the right side of your screen. Move your mouse pointer over this box, and it'll pop open showing you a thumbnail of the enlarged photo. Within this thumbnail is a white rectangle. The area inside the rectangle

is what's currently visible. To see other parts of the photo, click and drag the rectangle, or just click on another area of the thumbnail. If you want the zoom level to be greater or less than 100%, place your mouse pointer over the 100% label below the thumbnail, then click and drag up or down.

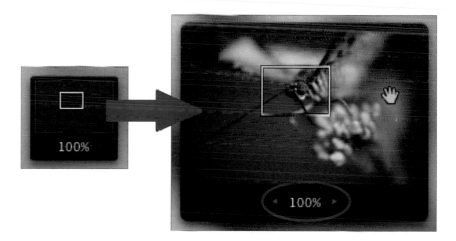

- **Method 2:** The second method is the simplest: Place your mouse pointer over the photo; then click and drag. This technique works as long as you're not using a tool. If you have a tool selected and you click and drag, you will be using the tool and not moving the photo. For example, if the Retouch tool is selected and you click and drag, it will apply the retouching, not move the photo.

- **Method 3:** The third method is a variation on Method 2. Hold down the spacebar; then click and drag to move the photo. This will work even if you have a tool selected.

Sorting photos

In the Browser and Split View modes, you can choose how you want the thumbnails sorted. At the top of the thumbnails section is a pop-up menu with sorting options.

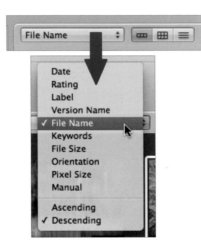

SORTING TIPS

- The pop-up menu also gives you options to sort the photos in ascending or descending order.

- If you drag and drop a thumbnail to change its position in a project, the sorting option will automatically change to Manual.

- The sorting option is project specific. This means Aperture will remember what sorting option you used for each project. For example, say I sorted my West Virginia project by Rating. Then I switch to my Ireland project and sorted it by Orientation. When I go back to the West Virginia project, it will still be sorted by Rating.

ZOOM TO THE RIGHT PART OF YOUR PHOTO

Place the pointer over the area you want to see enlarged; then press Z. When you do this, the area you pointed to will be centered on the screen at full size. If the pointer is not on the image and you press Z, Aperture defaults to bringing you to the center of your photo.

Stacks

Stacks is a helpful organizational and editing feature that allows you to group thumbnails together. Here's how it works:

1

Select multiple thumbnails that you want to group into a stack.

2

Go to Stacks > Stack (or press Command-K). This groups the selected photos into a stack. These thumbnails now have a dark gray background to indicate they are stacked together. Also, on the first photo in the stack, a number appears in the top-left corner. This number tells you how many photos are in the stack.

3

Close the stack to save space. Click the stack count number (top left) on the first photo. Then click the stack count number again to open the stack. You can also use the keyboard shortcut Shift-K to open or close a stack.

When a stack is closed, the only photo you see is the first one in the stack. Imagine the photos are in a pile, so you're looking down on them and you can see only the top one. The stack count number is what tells you this is a stack, not a single photo.

You can use stacks to consolidate sequences of photos such as portraits or action (sports, wildlife). This helps make a large number of photos more orderly; later you can edit the stacks and pick the best one. After selecting the best

shot of the sequence, you can delete the rest or simply move your pick to the top of the stack. The photo that's shown when the stack is closed (called the *Pick*) will always be the first photo in the stack. To change the Pick, you can drag a different photo to the beginning, or select the photo and go to Stacks>Pick (shortcut Command-\).

One way I use stacks is to group photos I've taken for High Dynamic Range (HDR), focus stacking, panoramas, or star

trails. For those types of images, I have multiple photos that are combined to create a final image. In the end all I need to see is the final product, but I still want to keep all the individual photos. By using stacks, I can keep the final image with the pieces. I make the finished photo the stack Pick, and if I need to see the rest of the photos, I just open the stack.

See the Stacks menu for additional stack functions and keyboard shortcuts.

STACKING TIPS (THE STACK MUST BE OPEN)
- Rearrange photos within a stack by dragging and dropping.
- Remove a photo from a stack by dragging it out of the stack.
- Add photos to a stack by dragging them into the stack.

Auto-stack

Aperture has an Auto-Stack feature that creates stacks for you based on the amount of time between photos.

1. Select the photos you want to auto-stack.

2. Go to Stacks>Auto-Stack.

3. The Auto-Stack Images window appears. Move the slider to set the maximum interval of time between photos. The slider scale goes from one second to one minute. Aperture will stack photos that were taken within the selected sequence of time. You'll see Aperture breaking the group into stacks as you move the slider.

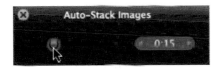

Selecting multiple photos in browser view

When you're working with your photos, sometimes you might want to select multiple photos. Perhaps you want to move them around or apply the same adjustment to all. Here are a few ways you can select multiple photos whenever they're shown as thumbnails. Which method is best depends on whether the photos you want to select are next to

each other or they're scattered. Try out each method to familiarize yourself with them.

• **Click and drag:** For photos that are next to each other, click in the gray area next to the first photo you want to select. Then drag the mouse across the thumbnails you want to select. A light gray rectangle will expand as you drag; all the photos the rectangle touches will be selected.

- **Shift key:** For photos that are next to each other, click on the first photo you want to select. Then hold down the Shift key and click on the last photo you want to select. All the photos between the first and last will be selected.

- **Command key:** For photos that are **not** next to each other, click on the first photo you want to select. Then hold down the Command key and click on the rest of the photos you want selected. Only the photos you click will be selected. Select a photo by mistake? Click it again to deselect it. You must keep the Command key held down during all selecting/deselecting.

Full screen

The full screen mode is a simplified interface that allows you to focus on working with your photos. To enter full screen mode, press the F key or click the Full Screen button in the toolbar. To exit full screen, press the F or Esc key.

In full screen mode, you either view your photos in Browser (thumbnails) or Viewer (single image) mode. Switch between these views by pressing the V key.

In the Browser mode, a navigation bar across the top allows you to switch between projects without leaving full screen mode. Click on Projects to see thumbnails representing each of your projects. Double-click a project to open it. When you're in a project, the navigation bar shows you the hierarchy of where that project is located in your library.

The navigation bar tells me the Golf project is within my Events folder. To go to another project within the Events folder, I click on Events, a drop-down menu appears, and I can choose the project I want to view.

The Full Screen Viewer mode is more of a Viewer–Split View hybrid. Basically, you always see the large image, but you can control when the thumbnail strip is visible. You have a few options for where the thumbnail strip is located and when you see it. If you don't see the thumbnail strip at first, try moving your mouse pointer to the bottom edge of the screen. The strip should pop up, overlapping part of

your photograph. If this doesn't happen, move the mouse pointer to the left or right edges of the screen. One of these three locations will make the strip appear. When you move the mouse pointer away from the edge, the thumbnails will disappear again.

If you don't want the thumbnail strip to automatically disappear, you can click a switch at the end of the strip to keep it visible. When the strip stays visible, the large photo will shrink in size so the strip doesn't cover it up. Click the switch again to return to the appear/disappear behavior.

You can also choose which side of your screen you want the thumbnail strip located. It can be on the left, right, or at the bottom. To change its position, click and drag the strip to a different side (click in the gray area between the thumbnails).

In the thumbnail strip, you cannot change the order of the photos by dragging and dropping. However, you can drag and drop in the Browser view.

At the top of the screen is a toolbar that has the same appear/disappear behavior as the thumbnail strip. To use it, move your mouse to the top edge to make it appear. It also has a switch at the end you can click to make it stay visible. This toolbar is made up of items from the regular toolbar as well as items normally seen at the bottom of the photo viewing area. These tools will be covered in later chapters.

The final item you have access to in the full screen mode is the Inspector, which gives you access to the Library, Metadata, and Adjustments panels. The Inspector can be visible in either the Browser or Split View modes. To show or hide the Inspector, press the H key. To switch panels, press the W key or click the panel name at the top of the Inspector. The Inspector can float on top of your photo, be moved to a second monitor, or be locked to

the left or right side of the screen. Click and drag the Inspector at the top to move it around. To lock it to a side, click the switch in the top-right corner.

Full screen mode with the Inspector, thumbnail strip, and toolbar visible.

INSPECTOR VANISHING TRICK

If the Inspector is floating on top of your photo, you can't see the whole photo as you make adjustments. Sure, you could lock it to one of the sides, but what if you don't want to? Here's a trick to avoid this inconvenience: Hold down the Shift key as you move a slider in the Adjustments panel. The entire panel fades away except for the slider you're working with. Now you can easily see your whole image and how the adjustment is affecting it. The panel will come back when you release the mouse button and/or the Shift key.

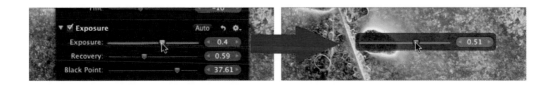

Displaying metadata with your photos

When you're looking at your photos, it can be helpful to have some metadata right there with the photo. That way, you don't have to go to the Metadata panel for info you frequently want to see. In all three of the viewing modes, you can have metadata displayed below the image.

To customize the metadata information under your photos, click the Metadata Overlays button in the tool strip below your photos; then choose Edit.

Let's first look at how to choose what metadata is displayed with your photos. Then we'll find out how to customize it for different viewing modes. In the Browser & Viewer Metadata window, there are two columns. The left column shows the metadata fields you can choose from. The right column lists the metadata that's selected to be shown with your photos.

The metadata fields are groups of metadata. Click the arrow next to a group to expand it and show the fields it contains. Check the boxes for the info that you want to see.

Each item that is checked will show up in the right-hand column. To remove an item from the right column, click the minus symbol next to it. This column also gives you control over the order in which the information is displayed. Drag and drop the items in the list to rearrange them.

- **Show metadata below image:** Leaving this option unchecked means the metadata will cover up the bottom of your photo.

- **Show metadata labels:** Selecting this option determines whether the different pieces of information are labeled or if just the info is shown.

Which option you choose is personal preference. I like to have the metadata below the image so it doesn't cover up the image. I don't show the labels because they cause the metadata to take up more space.

Top: No Labels **Bottom:** Show Labels

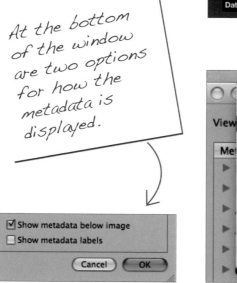

At the bottom of the window are two options for how the metadata is displayed.

Now that you know how to choose and arrange the metadata, let's go over the options for where and how it's displayed. At the top of this window is the View pop-up menu, which allows you to choose which metadata view you're editing. First, let's review the terms: Viewer is for the large single images (Split View or Viewer mode). Grid View refers to any thumbnails. List is one of the view options for how thumbnails are displayed (described earlier in the "Photo viewing modes" section).

Each of these groups has two views: Basic view and Expanded view. Aperture comes preset with certain metadata selected for each of these Basic and Expanded views (which you can see in the right column by selecting the different views). The names suggest Basic shows a little bit of info and Expanded shows a lot. Although this is how the metadata is set up by default, there isn't actually any restriction. You can choose a little or a lot of info for either the Basic or Expanded view. Although the naming is a little misleading in that respect, it is a good approach to setting up your metadata views.

It's important to know that you're not guaranteed all the metadata you select will be displayed. The different photo views (thumbnail, large image) have restrictions

as to how much info you'll see. Here's a summary:

- **Viewer (large image):** You can fit a lot of metadata below the large image. If you choose to have the metadata shown *below the image,* there can be up to three lines. If the info is shown *on top of the photo,* you can have more than ten lines, which really does get in the way of seeing the photo (if I need to see that much info, I'd rather use the Metadata panel). The first line will contain the following (if selected): rating, ISO, aperture, shutter speed, exposure compensation, focal length, badges, and color label. The subsequent lines will hold the remaining metadata. When the lines are full, any metadata that didn't fit will simply not be shown.

- **Grid view (thumbnails):** There are only two lines of info. The first line holds only the rating and badges (if chosen). The second line is everything else you selected. The second line will always stay below the thumbnail, even if you choose to have the info shown on top of the photo. Because thumbnails are small, not much is going to fit. Just like with the Viewer, if you select more info than can fit, it will not be shown. Likely, just one or two pieces of info will fit under a thumbnail.

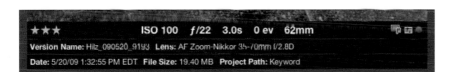

- **List (alternate thumbnail view):** Each piece of metadata selected has its own column. You can pack in lots of metadata here. However, if you pick too much info, each column will become so skinny that you can't easily read what's in the column. Then you have to widen the columns to see the data, which pushes other columns off the screen.

12/12/08 5:23:38 PM EST	Keyword	f/16	Manual E...	40mm	60.0mm	AF Zoom...	1/4	Daylight
12/12/08 5:26:17 PM EST	Keyword	f/16	Manual E...	35mm	52.0mm	AF Zoom...	1/5	Daylight
12/12/08 5:26:50 PM EST	Keyword	f/16	Manual E...	35mm	52.0mm	AF Zoom...	1/5	Daylight
12/12/08 5:39:51 PM EST	Keyword	f/4.5	Auto Exp...	35mm	52.0mm	AF Zoom...	1/10	Daylight
12/12/08 5:40:11 PM EST	Keyword	f/4.5	Auto Exp...	35mm	52.0mm	AF Zoom...	1/15	Daylight
12/12/08 5:41:02 PM EST	Keyword	f/4.5	Auto Exp...	58mm	87.0mm	AF Zoom...	1/10	Daylight

Having so much metadata to choose from and many different views to consider can be overwhelming. Think about what metadata is useful to you and experiment with different combinations to find out what best fits your needs.

- **Metadata tooltips:** Tooltips is a floating window of metadata. It shows up next to your mouse pointer whenever you point at a photo (thumbnail or large image). The metadata is always labeled, and each piece of information is on a separate line. Sometimes it's helpful to have this information front and center; other times it's a bother to have a box of data pop up.

Finally, we'll look at one last menu for Metadata Overlays that puts all the options we've been working with to use. Let's go back where we began: the Metadata Overlays button in the tool strip below your photos. The choices in the pop-up menu depend on the viewing mode. Here are the variations you'll see:

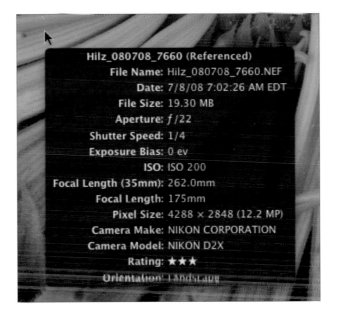

Quickly turn Tooltips on and off by pressing the T key.

Viewer	
✓ Show Metadata	Y
Switch to Basic View	⇧Y
Show Metadata Tooltips	T
Edit...	⌘J

Viewer

Browser	
✓ Show Metadata	U
Switch to Basic View	⇧U
Show Metadata Tooltips	T
Edit...	⌘J

Browser

Viewer	
✓ Show Metadata	Y
Switch to Basic View	⇧Y
Browser	
✓ Show Metadata	U
Switch to Basic View	⇧U
Show Metadata Tooltips	T
Edit...	⌘J

Split View

No matter the viewing mode you are in, the options are consistent. The first option, Show Metadata, controls whether the metadata is visible or hidden. The checkmark means it's visible. To hide the metadata, click Show Metadata, and the checkmark disappears (repeat to bring it back). The second option, Switch to…, allows you to toggle between the Basic and Expanded views you set up. If it says Switch to Basic View, that means you're currently using Expanded view, and vice versa.

Conclusion

As you can see, Aperture gives you plenty of options for viewing your photos. The full screen mode in particular is an elegant interface that clears out distractions, allowing you to focus on working with your images. As you spend more time using Aperture, it'll become more clear how you personally can best take advantage of the options discussed—for example, which viewing modes you prefer, how stacks will fit into your editing process, and what metadata is most helpful for you to see regularly. Now that you know where to find things in Aperture, the next chapter will turn to organizing your photos.

Chapter 3: Organization and Backup

ORGANIZATION IS CRITICAL to any photo-graphic workflow. What good are all the wonderful ways you can enhance your photos if you can't find them? Organizing your images may not be exciting, but it sure can make life easier. Aperture's organizational tools are projects, folders, albums, and smart albums. Each has a different purpose, and in this chapter, you'll learn how to get the most out of them. Utilizing all these tools allows you to create a flexible and functional system.

Just as important as organizing (or maybe more so!) is backing up. After you spend time adjusting, enhancing, and organizing, you should make sure you don't lose that information. Using Aperture's Vault feature is the way to make sure this doesn't happen. All the features covered in this chapter are located in the Library panel.

CREATE PROJECTS, FOLDERS, ALBUMS, AND SMART ALBUMS

Keyboard Shortcuts:

- New Project: Command-N
- New Folder: Shift-Command-N
- New Album: Command-L
- New Smart Album: Shift-Command-L

Menu: File>New; then choose what you want to create.

On-screen: In the toolbar, click the New icon to open a drop-down menu.

Projects

- Projects are containers for photos.
- Photos can be moved from one project to another. Select the photos you want and then drag them to another project name in the Library panel.
- A photo can be in only one project at a time.
- Projects can also contain folders and albums.

To show a count of how many photos are in each project and album, go to the Appearance section of Preferences (Aperture>Preferences). Check the box labeled Show number of versions for projects and albums.

GSMNP 07 spring
Charleston 09
GSMNP 09 september
IN 09
Ireland 10

New England 09	1784
NJ 09	179
st mikes 10	2124
WV Fall 09	3245

PROJECT INFO

To bring up the project info for a selected project, do one of the following:

- Keyboard Shortcut: Shift-I
- Menu: Window>Show Project Info

An info box for the project pops up. Here, you can change the project name, enter a description, and assign a location. You can also set the key photo by moving the mouse across the thumbnail to scan the photos; then click the one you want. The arrows at the bottom are used to move to the previous or next project.

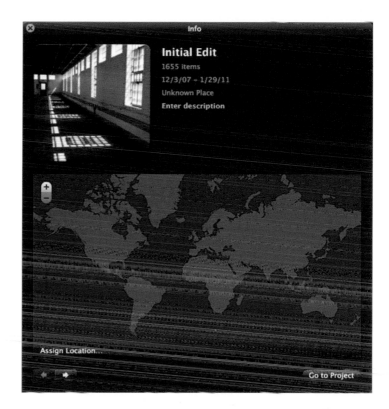

Folders

- Folders can contain projects and/or albums.
- Folders cannot contain photos (if you drag a photo to a folder, nothing will happen).
- Folders are used for organizing your projects and albums.

Albums

- Albums hold virtual copies of your photos. To add photos to an album, drag them from a project to the album. The photo stays in the project, but it is also included in the album. Albums are great for both long-term and short-term grouping of your photos because you can easily gather images from various projects.

- When you put a photo in an album, it is not actually moved; it always stays in its project. Aperture simply makes a note of which album(s) the photo should appear in.

- You can place the same photo in multiple albums because

Aperture does not actually move the photograph.

- If you don't want a photo in an album any longer, go to the album, click on the photo, and press the Delete key. The photo will disappear from the album. When a photo is deleted from an album, you don't delete it from the library, just that

album. It's still in the project you dragged it from initially (as well as any other albums you placed it in).

- If you **do** want to send a photo directly from an album to the Trash, press Command-Delete or right-click (Control-click) and choose Delete Version.

CREATE AN ALBUM FROM SELECTED PHOTOS

- Select the photos that you want to go in a new album.
- Go to File>New>Album (or use the New button in the toolbar). You'll be prompted to give the album a name.
- Make sure the Add selected items to new album box is checked.

Albums and stacks

If a photo is part of a stack and you drag it to an album, all the images in the stack go into the album. Deleting a stack from an album can be tricky. When a stack of images is in an album, you cannot delete one photo from the stack (to remove it from the album). You have to delete the entire stack at once from the album. The easiest way to do this is to close the stack and then select it and press the Delete key. If the stack is open, you must select all the images in the stack and then press Delete.

This process can be particularly confusing if you had two images in a stack and then rejected (giving it a Rating of 9) one of the images while it was in the album. To successfully remove the remaining image from the album, close the stack and then press Delete. Because there appears to be only one image in the stack, it may not seem as though the stack is open, but it is. You can just close it as you would any other stack.

Smart albums

- Smart albums are basically saved searches.

- How they're the same as regular albums: The photos they hold have not been moved; they are still in their designated projects.

- How they're different from regular albums: You don't add photos to a smart album by dragging and dropping; Aperture finds the photos for the smart album based on search criteria you choose.

- Smart albums are purple; regular albums are blue.

Under the Project & Albums group, there's a set called Library Albums. These are all preset smart albums. To see the criteria Aperture used to create them, click the magnifying glass next to the album name.

Creating a smart album

When you create a smart album, a Smart Settings box pops up. In that box you choose the criteria you want to use to find photos. You can search for photos based on Ratings, Labels, Keywords, and more. You can choose one, two, five, or more criteria; it's up to you how broad or narrow the search is. To see additional search criteria, click the Add Rule box in the top right.

Near the top of the Smart Setting box is a section labeled Source. The Source choice tells you where the album will search. Library will always be a choice. With Library selected, the album will search your entire photo library. If the smart album is within a project, the name of the project will be next to Library. If you select the project name, the album will search for photos only in that project. If you move the smart album to another project, the project name listed will change to match the current project. Therefore, if you want a smart album to search only within a particular project, you must place the album inside that project.

Combining projects, albums, smart albums, and folders

To make the most of the organizing tools available to you, think about how you can combine them. Folders are a big help for grouping projects, albums, and smart albums. You could also have folders within folders. Let's look at some examples.

Deciding how to group your photos into projects is a key part of a good organizational system. Common approaches include naming projects by month, date, or location. In the following examples, I used a folder to

group my projects from 2010. One example shows naming projects by month; the other, by location. Pick a system that works best for you.

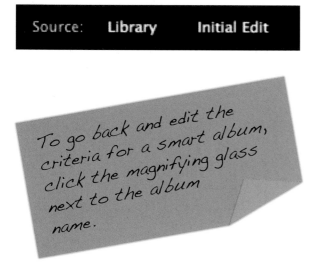

To go back and edit the criteria for a smart album, click the magnifying glass next to the album name.

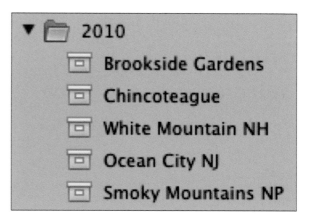

I could take this organizational scheme a step further and have the months also be folders and then inside the month folders have projects named by location. Here's what that would look like:

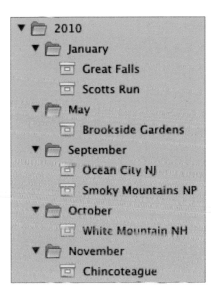

In the next two examples, I used folders to group smart albums and regular albums. Of course, a folder doesn't have to contain only one type of organizer. You could mix projects, albums, and smart albums within a single folder. I created a Searches folder for smart albums that I will

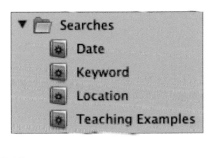

reuse and that aren't specific to a particular project. The Website Galleries folder contains albums that contain the photos I'll put on my website.

Backing up: Protecting your library and photos

Backing up your digital photos is a critical part of your workflow. As mentioned in Chapter 1, you can back up your photos when you import. However, this doesn't back up all the settings, adjustments, thumbnails, and previews that make up your Aperture library.

Aperture's Vault feature allows you to back up your Aperture library. Vaults are a compressed version of your library. If you store your photos as Managed Files, then your photos and their settings will be backed up in the vault. If your photos are Referenced Files, only the settings (adjustments, metadata, previews, and so on) are backed up; you must back up your actual photos separately.

The Vault feature is located at the bottom of the Library panel. Click the middle icon with the triangle to show the vaults.

1

To create a vault, go to the Action menu (gear icon) on the right and choose Add Vault. A message pops up telling what will and will not be backed up in the vault. Click Continue.

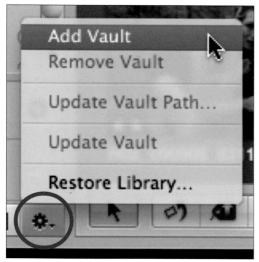

2

Name your vault, choose where you want to save it, and then click Add. Vaults should not be placed on the same hard drive where your Aperture library is located. For example, if your library is on an internal hard drive, save the vault to an external hard drive.

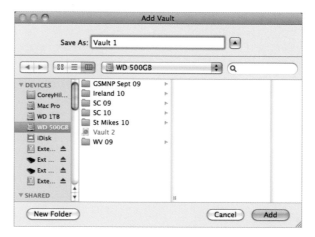

3

Update your vault. When you first create a vault, your Library is not backed up; Aperture has simply created an empty vault. Click the circular double arrow icon; then Aperture will confirm that you want to update your vault(s). The first vault update takes a long time because that is the initial copying of all the information.

You can have multiple vaults. A second backup offers extra security. Just remember to save each vault on a different hard drive.

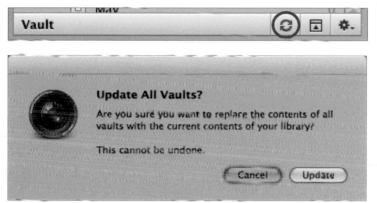

Update All Vaults?

Are you sure you want to replace the contents of all vaults with the current contents of your library?

This cannot be undone.

Cancel Update

VAULT TIPS

- After the first vault update, Aperture updates only the changes you've made to the Library (since the last update), so updates don't take a long time.

- You have to choose to update your vault; updating cannot be done automatically.

- If something happens to your Aperture library, you can use your vault to restore the library. First, go to the Action menu (gear icon) for the vault and choose Restore Library; then tell Aperture where the vault is located. Aperture will restore all your settings, adjustments, and any photos that were Managed Files.

Vault icons

Arrows: Vault status button. Click this button to update the vault.

- Red: The vault is not up to date; photos have been moved, added, or deleted.

- Yellow: The vault is not up to date. Only settings or adjustments have changed; no photos have been moved, added, or deleted.

- Black: Everything is up to date.

Triangle: A button to show or hide the vault list.

The list tells you how much free space remains on each vault. Also displayed is the circular arrow icon indicating the status of the individual vaults. If you update all your vaults at the same time, they'll always have the same status.

| Vault 1 | 11.1GB of 931.4GB available |
| Vault 2 | 174.6GB of 465.6GB available |

Vault

Gear: Action menu.

These are options for adding, removing, updating, and restoring vaults.

Add Vault
Remove Vault

Update Vault Path...

Update Vault

Restore Library...

Conclusion

Taking the time to develop an organizational system with projects, folders, albums, and smart albums that works for you is worth the effort. This system will make it easier to find your photos and let you focus on working with them, which we'll begin exploring in the next chapter. And don't forget about that backup to give yourself some peace of mind!

Chapter 4: Standard Image Adjustments

It's TIME TO begin editing and adjusting your photos! In this chapter we'll work in the Adjustments panel as we go through the initial image review and adjustment process. The first steps include rating and labeling, checking focus, cropping, straightening, removing red eyes, and retouching. Then we'll move on to color and tone adjustments such as White Balance, Exposure, Brightness, Contrast, Saturation, Levels, Highlights & Shadows, and Color.

No SAVING REQUIRED

There is no need to save the changes to your photos; actually, there's not even an option for this action in the menus. Sound strange? In Aperture, the "saving" process is automatic. When you make an adjustment to an image, the settings are immediately recorded (saved) in the Aperture library. Easy as that. One less thing to have to think about!

> When editing photos, I prefer to use the Split View mode, where a strip of thumbnails appears along with a large version of the selected image. Press the V key to cycle through the view modes. As you edit, you can navigate through the thumbnails using the arrow keys.

Adjustments panel layout

The information shown in the Adjustments panel is for the currently selected photo. If multiple images are selected, the settings are shown for the image thumbnail that has the thick white border. Click on a different photo in the group to change which one has the larger border.

At the top of the Adjustments panel is the histogram; you'll see it change as you make adjustments to the photo. Underneath the histogram is a group of camera settings: ISO, aperture, shutter speed, and lens focal length.

Also in the top portion of the panel are buttons for two pop-up menus: Presets and Adjustments. The Presets menu contains saved adjustment settings that you can apply to your photos. We'll look at creating and using presets in the next chapter. The Adjustments menu has a list of all the adjustments you can use. The adjustments with the circles next to them are the ones currently displayed in the Adjustments panel.

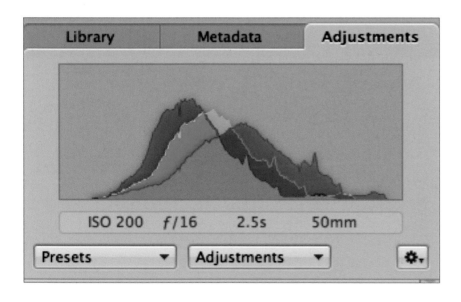

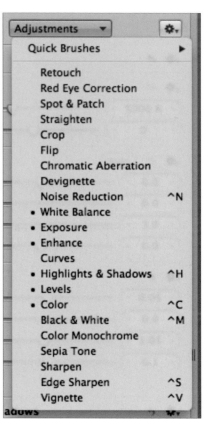

A little terminology to be familiar with here: Each of the adjustments is called a *brick* when it's displayed in the Adjustments panel. A brick may contain one or more settings. For example, there's the Exposure brick, the Enhance brick, and so on. There are six default bricks: White Balance, Exposure, Enhance, Highlights & Shadows, Levels, and Color. The default bricks are the ones that are always in the Adjustments panel.

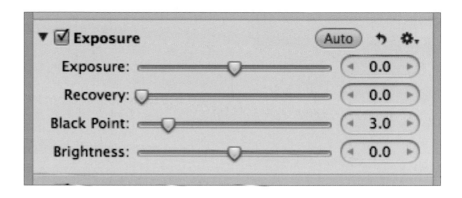

Tips for working with the bricks

- Each brick has a checkbox next to its name. Click the checkbox to turn off the adjustment; click the box again to turn it back on. Toggling this checkbox is an easy way to see a "before and after" comparison, specific to one brick.

- Next to each brick's checkbox is an arrow. Click the arrow to open or close the brick. Close a brick to save space.

- To reset a brick to its default settings, click the curved arrow in the top-right corner of the brick.

- The gear icon in the corner of each brick is the Action pop-up menu with options specific to that brick.

- Some bricks have an Auto button at the top. Click the button, and Aperture adjusts the setting in the brick to what it "thinks" is best for the photo. Doesn't hurt to try it out and see what Aperture comes up with. If you don't like the results, you can always reset the brick or fine-tune the individual sliders.

- Double-click a slider to reset it to its default setting. This technique is much faster than having to drag the slider back to zero.

- To delete a brick (and remove its adjustments), first make sure it's selected by clicking anywhere within the brick; then press the Delete key. This will delete only adjustment bricks that are **not** part of the default set. Doing this to a default brick will reset the adjustment but not remove it.

- If you find that you don't use one of the default bricks regularly, you can remove it from the default set. Click the Action menu for the brick (gear icon) and choose Remove from default set.

- You can also add bricks to the default set. Choose an item from the Adjustments pop-up menu. Then go to the Action menu for that brick (gear icon) and choose Add to default set.

Heads up display (HUD)

When you use most of the tools in Aperture, a brick will appear in the Adjustments panel with the settings for that tool. In addition, there may also be a dark gray window that floats over the Aperture window. This window, called a Heads Up Display (HUD), will contain the same settings as the brick and/or additional settings. When I discuss these tools, I'll refer to settings in the "HUD." For example, a HUD will appear when using the Red Eye Removal tool, Retouch brush, and Crop tool, among others. You can close a HUD by clicking the X in the top-left corner. You'll also see HUDs appear when working with other features of Aperture, such as keywords.

If you want even more space for your photos, you can hide the Inspector (Library, Metadata, and Adjustments panels). Press the I key to hide the Inspector; press I again to bring it back.

File format

The photographs you import from your memory card will be in one of two image formats: JPEG or RAW. I prefer to shoot files in a RAW format because the files contain more information, which can produce better quality results when making tone and color adjustments, especially when the changes are substantial. The image adjustments we'll use in this chapter and the next work the same whether your files are RAW or JPEG. So no matter what file type you're shooting, Aperture makes it easy to bring out the best in that image.

Quick preview mode

You may notice a delay in how quickly the large preview photo renders when going from one image to the next. The image might appear a little soft and then "snap" to a sharp version after a couple of seconds. What's happening is that Aperture is loading the full-resolution image, but sometimes Aperture can't do that immediately. This delay is more likely to occur if you are working with RAW files because they have larger file sizes. To avoid this delay, you can turn on the Quick Preview mode.

In Quick Preview mode, Aperture shows you the preview image it created when you first imported the photo. Accessing the preview image is much faster than rendering the full-resolution image. You won't notice any lag when moving through your photos. In Quick Preview mode, you can't work in the Adjustments panel (adjusting the image requires using the full-resolution image). This mode is good for an initial review of your images, including adding ratings and labels, along with any other metadata.

Press the P key or click the Quick Preview button at the bottom of the Aperture window. Press P again or click the button to exit Quick Preview mode.

In Quick Preview mode, the selected thumbnail has a yellow border instead of a white one. This is a convenient visual reminder that you're seeing the preview version of the photo.

Also, if you go to the Adjustments panel when Quick Preview is on, you'll see a reminder at the top of the panel that the adjustments are disabled.

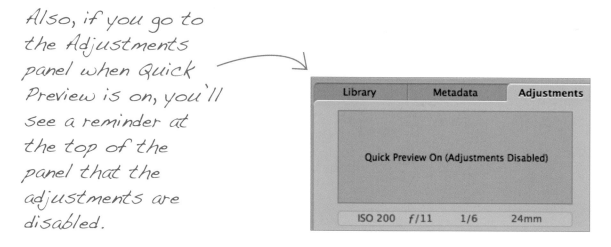

Deleting and rejecting

When you're initially reviewing your photos, this is a good time to get rid of images that are clearly not keepers: the accidental photo of your shoe, an obviously out-of-focus shot, or a grossly over- or underexposed image. When you find a photo you want to get rid of, you can delete it or reject it. To delete a photo, press Command-Delete, or go to File>Delete Version. This sends the photo to the trash within Aperture.

Alternatively, rejecting photos can be an intermediate step before actually sending them to the trash. You can reject photos to get them out of the way, review the rejected photos later, and then trash them. To reject a photo, press the number 9 key. This places an X in the bottom-left corner of the selected image. When you move on to the next photo in the thumbnail strip, the rejected photo will disappear.

When reviewing your rejected photos, you have the opportunity to "unreject" any photos you've changed your mind about. Select an image and press 0 (zero), or give it a star rating. As soon as you click on another one of the rejected images, the "unrejected" photo will disappear from the album and be visible back in its project.

To review your rejected images, go to the Library Albums group in the Library panel and select Rejected.

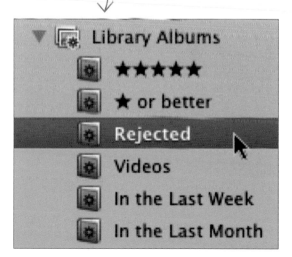

After you review your rejects and "unreject" any photos you've changed your mind about, it's time to send them to the trash. Select all the photos (press Command-A or go to Edit>Select All); then press Command-Delete. They will disappear from the Rejected album and go to the trash. You can click on Trash in the Library panel to see the trashed images.

When you're ready to permanently delete the photos in the trash, go to Aperture>Empty Aperture Trash or press Shift-Command-Delete. A confirmation dialog will appear. Click Delete to finish the deleting process. If you are deleting Referenced Files (photo files are not stored in the Aperture library), there will be a checkbox labeled Move referenced files to System Trash. Make sure this option is checked to ensure that the original photo files will be moved to the trash along with the photo settings and previews from Aperture.

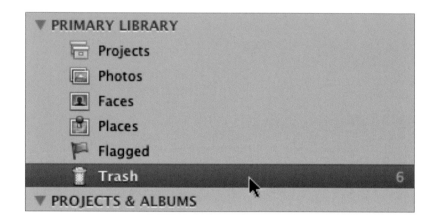

Ratings and labels

Ratings and labels are two features that can be helpful in the editing process. Ratings add a star ranking to your photos. You can give a photo zero to five stars. How you use ratings is really personal preference. Choose a system that makes sense to you. For instance, you can use stars to rate the quality of the photo: 1 star: okay, 3 stars: good, 5 stars: the best. Or you could use this scale but with one, two, and three stars. You could

make it even simpler: 3 stars: it's a keeper, 1 star: you're going to delete it (an alternative to using 9 for rejecting). Give some thought to what would work best for you.

To add a rating, use the number key for how many stars you want to give the photo. For example, press the 3 key to assign three stars. If you want to change a rating, just press a different number key. To remove all stars, press zero. Alternatively, you can choose a rating from the Meta-data menu, or right-click the

image and choose a rating from the pop-up menu.

A label is a color assigned to a photo. You can choose from five colors; a photo can have only one label. The options for how to assign a label are similar to adding a rating. You can use a keyboard shortcut: Command-1 through Command-7. To remove a label use Command-0 (zero). Alternatively, you can choose a label from the Metadata menu, or right-click the image and select a label from the pop-up menu. In the Metadata menu or pop-up menu, you can see the colors available. Also, when you point your mouse at one of the colored circles, two useful pieces of information are displayed. To the right of the colors is the keyboard shortcut for that label. Under the colors, the name of the label shows up. By default, these are the colors of the labels.

Hilz_100501_6442

For thumbnails, the label is displayed as a colored stripe under the image. When looking at a photo in the Viewer or Split View modes, you'll see the label as a color circle in the corner of the large image.

To change the names of the labels, go to the Labels section of the Preferences (Aperture> Preferences).

Checking focus

One of the first things to do when working with an image is check whether your photo is in focus. If a photo is significantly out of focus, that will be readily apparent. But what if it is just a little bit soft? You may not be able to tell when the photo is at a regular viewing size for your monitor.

Using the Loupe tool makes it easy to check focus. The Loupe shows you a magnified view of part of your image. Here are three ways to display the Loupe:

- Press the tilde (~) key (to the left of the "1" key).
- Choose View > Show Loupe.
- Click the Loupe button in the toolbar.

I find using the tilde key the most convenient. Press the key to show

the Loupe; then press it again to hide the Loupe. You move the Loupe around by clicking and dragging the Loupe's dark border.

Seeing the entire image at once.

Loupe showing a portion of the photo at 100%.

CHANGE THE LOUPE SIZE

You can also change the size of the Loupe. Next to the pop-up menu, there are a few gray lines in the corner. Click and drag on the lines to change the Loupe size. Drag toward the Loupe to make it smaller; drag away to make it larger. I keep the Loupe as big as possible so I can see the largest magnified area at once.

To see the Options menu for the Loupe, click the number at the bottom right of the tool. The top two choices in the menu, Focus on Loupe and Focus on Cursor, control how you use the Loupe.

- **Focus on Loupe:** You place the Loupe over the part of the photo you want to magnify. You click and drag the Loupe to magnify different parts of your photo.

- **Focus on Cursor:** The Loupe stays in one place, and you use your mouse to point at the part of the photo you want to magnify (you can reposition the Loupe by clicking and dragging its border).

I find Focus on Cursor more useful for a few reasons. First, I don't have to click and drag the Loupe around. I just point; no clicking required. Second, this tool allows me to see precisely which part of the photo I'm magnifying. Third, I can easily use the pointer to check image details no matter whether I'm using Browser, Viewer, or Split View mode. Both options are effective methods of using the Loupe; the choice really comes down to personal preference.

The percentages are how much the Loupe magnifies the area it's showing. Choose 100% for checking focus so that you will see your photo at full size. Amounts larger than 100% are not good for checking focus because you are magnifying the image too much. Even a sharp image will look fuzzy if you view it beyond 100%.

Now that's you're familiar with how to use the Loupe, start checking your photos. Move the pointer (or Loupe) to magnify the area(s) that should be sharp. If it's not sharp, consider whether you want to keep the photo. The image may look good at a small size on a website, but if you try to print it, the lack of sharpness will be readily apparent.

Rotating your photos

Cameras embed information in the metadata to tell Aperture whether you took the photo as a vertical or horizontal shot. Most of the time, this works as it should, but sometimes when you import your photos, a vertical image is shown horizontally because the camera didn't correctly recognize which way you had it positioned. The good news is Aperture makes it easy

to rotate your photos. All you have to do is press the left or right bracket keys to change your photo from vertical to horizontal, or vice versa. The left bracket key ([) rotates the image counter-clockwise; the right bracket key (]) turns it clockwise. Each press of a bracket key rotates the photo 90 degrees. You can also find these choices at the top of the Photos menu.

Rotate multiple photos at once by selecting the photos first and then pressing the left or right bracket key.

ROTATING FOR CREATIVE EFFECT

You can also rotate your photos for creative effect. Abstract compositions often aren't tied to a particular orientation, giving you the flexibility to rotate the photo and see what looks best. Consider the leaf photos on this page, for example. The orientation of the photos affects how your eye moves through them. They're all possible interpretations of how to view the leaf.

Straighten tool

If your picture is tilted to the left or right, you can use the Straighten tool to fix it. Correcting a photo with a slanted horizon line is a common use for this tool.

1

Select the photos and then choose the Straighten tool: Click the button for the Straighten tool at the bottom of the Aperture window or use the keyboard shortcut G.

2

Click and drag up or down to straighten the photo. When you drag, a grid will appear, helping you with straightening your photo. Use the gridlines as a reference for what is a straight horizontal or vertical line. After you've aligned your photo with the grid, release the mouse button and your photo is straightened. Press the Return key to deselect the Straighten tool. You can always go back and adjust the straightening by selecting the Straighten tool again.

STRAIGHTENING: BEHIND THE SCENES

Aperture makes the straightening process as easy as clicking and dragging, but what did it actually do here? First, it rotated the photo as you saw on the screen. Then it cropped off the corners to keep the photo the correct rectangular shape. What this means is every time you need to straighten a photo, you lose some of it. The more straightening you have to apply, the more of the photo you lose. So it's best to have the original photo as straight as possible.

When you use the Straighten tool, Aperture adds a Straighten brick to the Adjustments panel. You can also use the Angle slider in the brick to adjust the straightening of the photo.

Cropping

Are there distracting elements around the edges of the photo? Did you include more than you wanted to in the composition? Will cropping produce a better image? These are a few reasons to crop.

Cropping (and other adjustments you make to your photo in Aperture) can always be changed later. When you crop in Aperture, you do not actually get rid of the rest of the photo. A note is made to specify which part of the photo you want to show. You can come back a week or month later and change the crop or remove it entirely.

Select the Crop tool: click the button for the Crop tool at the bottom of the Aperture window or use the keyboard shortcut C.

Click and drag on your image to draw a crop box. Draw the box roughly where you want it. Don't worry about getting it just right because you can fine-tune the shape and position.

Remember that the more you crop, the less information (pixels) you end up with in your final photo. Cropping away a large amount of your photo can limit the print size you can produce.

3

To adjust the size of the crop box, place your mouse cursor over one of the squares along the edges of the crop box; then click and drag to change the size. When you're done, press the Return key to deselect the Crop tool. You can always go back and adjust the crop by selecting the Crop tool again.

Proportional cropping

The Crop tool's default settings allow you to draw a crop box that has the same proportions as your original image. This capability is useful if you want your cropped photo to be the same shape as the original. When you keep the same shape, it won't be apparent (from the shape of the photo) that you cropped the image. If you don't want your crop to be proportional, you need to change the Aspect Ratio in the Crop HUD, the floating dark gray box that appears when you select the Crop tool.

The Aspect Ratio is set to Master Aspect Ratio by default, which is what creates the proportional crop box. Click Master Aspect Ratio to display a pop-up menu; then choose Do Not Constrain. Now you can make your crop box any proportion you want.

The Aspect Ratio pop-up menu also includes presets for cropping to proportions different from your original photo. These presets are useful if you want to make sure your cropped image fits a particular proportion. For instance, 2 to 3 is the proportion for a 4×6 photo, and 4 to 5 is the proportion for an 8×10 photo.

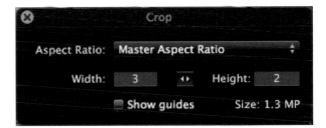

ADJUSTING THE CROP BOX

- To change the size of the crop, click and drag the squares found at the sides and corners of the crop box. The squares in the middle of the sides will resize in one direction (vertical or horizontal). The corner squares allow you to resize in both directions at once. Note: Unless the Aspect Ratio says Do Not Constrain, the crop box will resize vertically and horizontally no matter which square you drag.

- To move the entire crop box (and keep its shape), click and drag in the middle of the box.

- To remove a crop, click once on any part of the photo outside the crop box.

Check the box labeled Show guides in the Crop HUD to display the Rule of Thirds grid within the crop box.

Red eye removal

Red eyes in people (caused by the flash) are an annoying distraction. The Red Eye tool makes it easy to eliminate.

1

Press Z to enlarge the image to full size so you can easily see the eyes you want to correct. If the area of the enlarged image doesn't include the eyes, click and drag the photo to move around the image.

Select the Red Eye tool: click the button for the Red Eye tool at the bottom of the Aperture window or use the keyboard shortcut E.

3

Your mouse pointer becomes a circle with a crosshair symbol in the center. Adjust the Radius slider in the Red Eye HUD to make the circle about the same size as the eye. If your mouse has a scroll wheel, you can also use that to change the Radius. A scroll wheel makes it easier because you can keep the circle on the eye while adjusting the size. If you're using a laptop, you can do this by placing two fingers on the trackpad and sliding them up or down.

4

After adjusting the radius, place the circle over the center of the eye you want to fix. Click once to apply the red eye reduction. Aperture places a yellow circle around the eye to indicate the Red Eye tool has been used.

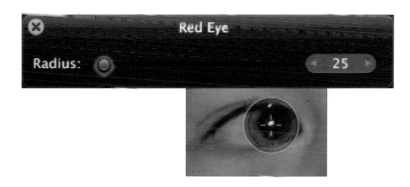

To fine-tune the red eye removal, go to the Red Eye Correction brick in the Adjustments panel. In the brick, you can change the Radius as well as use the Sensitivity slider to adjust how the red is removed. You can see the real-time effect as you move the sliders. This makes it easy to tweak the appearance of the eyes.

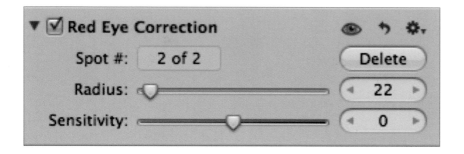

RED EYE CORRECTION TIPS

- To move one of the yellow circles, select the circle by clicking on it; then click and drag the circle to reposition it.

- If you want to go back and change the Radius or Sensitivity, make sure the correct eye is selected. Click inside the yellow circle around the eye. The selected circle will have a thicker yellow border.

- To delete a red eye correction, select the yellow circle you want to remove; then go to the Red Eye brick and click the Delete button.

- When the Red Eye tool is not selected, the yellow circles are hidden. If you go back to the Red Eye tool, they'll reappear.

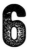

Repeat as necessary for other eyes. A yellow circle will remain around all eyes that have been corrected. When you're done, press the Return key to deselect the Red Eye tool. You can always go back and work with the red eye removal by selecting the tool again.

Retouch brush

The Retouch brush combines two tools that give you the ability to easily repair areas of your photos. The Retouch brush is not for complex tasks, but for small, quick fixes. The Retouch Brush HUD offers Repair and Clone options. When you're using the brush, the pointer changes to a circle.

Select the Retouch brush by selecting Retouch from the Adjustments pop-up menu at the top of the Adjustments panel. You can also use the keyboard shortcut X.

Repair

The Repair option is the more automated of the two choices of the Retouch Brush HUD. It copies texture and blends color from around the brush. It has a function similar to Photoshop's Spot Healing brush. The Repair option is particularly useful for removing sensor spots. No matter how careful you are about changing lenses, eventually you'll start seeing small dark spots on your photos. The Retouch brush saves you from having to use an external editor, such as Photoshop, just to remove a dust spot in the middle of a blue sky. You can also use the tool to remove skin blemishes.

1

When you're looking at the entire photo, it may not be easy to see all the sensor spots. This image has numerous spots in the sky. Press Z to enlarge your image to full size so you can easily see the spots you want to remove. Click and drag to move to different areas of the photo.

2

Select Repair in the Retouch HUD. Make sure the Automatically choose source and Detect edges options are both checked. Move the Radius slider to change the brush size. Choose a brush that is a little larger than the element you want to remove. Set the Softness to 0.50 and the Opacity to 1.00.

3

Click once on the sensor spot, and it disappears. In most cases, that's all you'll need to do. Repeat for other sensor spots, remembering to keep the brush a little larger than the spot. Soon all your spots will be gone.

If these steps don't produce good results, you may need to manually select where Aperture is sampling from. Uncheck Automatically choose source in the Retouch HUD. You now need to hold down the Option key and then click on the area where you want Aperture to sample texture and color from (Aperture provides a friendly reminder of this at the bottom of the HUD). Then use the tool as just described.

If the area you are trying to repair has a lot of detail, you might find it necessary to adjust the Opacity and Softness sliders from the settings I suggested. A lower softness amount gives the repaired area a more defined edge. Increased softness results in a smoother transition around the edges of the repaired area. At full opacity (1.00), the Retouch tool completely covers up an area of the original photo with sampled color/texture. A lower opacity setting blends the original photo with sampled color/texture. The lower the opacity, the more the original photo shows through the retouched area.

CHANGING BRUSH SIZE

When using the Retouch brush, if you have a mouse with a scroll wheel, you can change the size of the brush by turning the wheel when the brush is over the photo. If you're using a laptop, you can do this by placing two fingers on the trackpad and sliding them up or down. This is faster than using the slider, and you don't have to move your brush.

Clone

The Clone option of the Retouch Brush HUD is used for copying part of an image and then pasting it over another area in the image. There is no matching texture or colors, just an exact copy of what you chose to clone. For example, you could duplicate a bird in the sky or add another flower to a stem. However, cloning can also be used for fixing things, such as when the automated Repair option isn't doing a great job. The steps for cloning are similar to using the Repair brush, except that you have to tell Aperture where to clone from (just like when you uncheck Automatically choose source for the Repair brush).

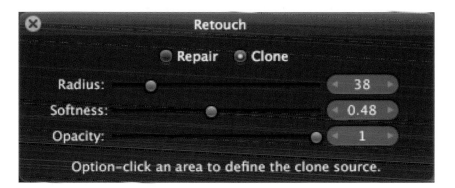

In this photo, there are contrails in the top right. I ended up having to use the Repair and Clone options to remove them.

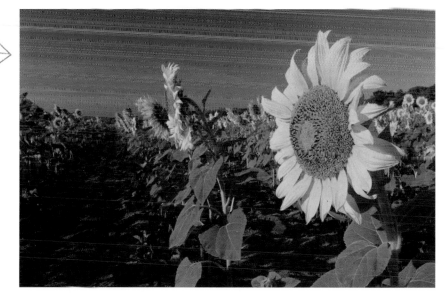

Detail of the corner of the photo so you can better see the contrail.

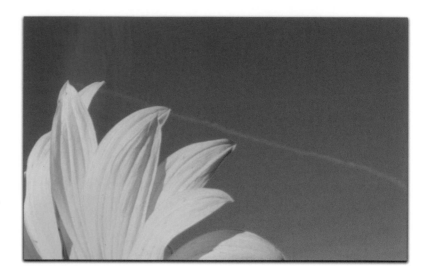

Here are the results of using the Repair option. The brush had no trouble where the contrail was surrounded by blue sky, but when it got close to the sunflower petals, the results weren't so great. When I used the Repair brush right next to the petals, Aperture sampled the yellow and the blue and left a little of both. This type of poor result is where cloning comes in handy.

For the sunflower photo, I selected the blue sky just above the petals as my clone source. This way, I knew Aperture would use only blue when I applied the cloning. I clicked over the offending yellow areas and turned them back to blue.

Cloning steps

1. Press Z to enlarge your image to full size so you can easily see the areas you want to retouch. Click and drag to move to different areas of the photo.

2. Select Clone in the Retouch Brush HUD. Move the Radius slider to change the brush size. For more natural cloning, pick a brush that is smaller than what you want to clone. Set the Softness to 0.50 and the Opacity to 1.00.

3. To use the Clone brush, you first need to set the source; the source is where the Clone

brush will copy from. To set the source, hold down the Option key. The brush will change to a plus sign. Move the plus sign to where you want the source to begin, and then click once. I say "begin" because the source does not stay locked in place; it moves with the brush.

4. Use a series of clicks and/ or click and drag to do the cloning. If you're not getting good results, try selecting a new clone source. For more extensive cloning jobs, it can be helpful to change the size of the brush and select new sources as you go. This will produce better quality results and reduce the likelihood of artifacts (unwanted tones and textures). Also, as I mentioned with the Repair option, experiment with different Softness and Opacity settings.

Deleting retouching

You can also delete your retouching steps through the Retouch brick in the Adjustments panel.

The Stroke number tells you how many different separate clicks or drags you did with either of the retouching options. Clicking Delete will undo the last retouch

CLONING TECHNIQUE

In most cases you're not trying to clone something out in a single click with a big brush. You want to use a series of single clicks or small click-and-drag maneuvers. If you pick a brush the same size as what you're cloning, the result often won't blend in with the rest of the surrounding area. It'll look as though you stamped something onto the picture.

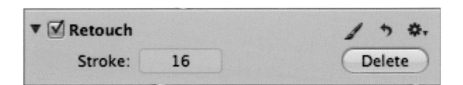

Keep an eye on the location of the source to make sure you're cloning from the right area. You might need to stop and choose a new source as you're cloning.

step. Each time you click Delete, one more retouching step is undone. You can only delete steps in the reverse order you did

them; you can't pick and choose which steps to delete. Also, there is nothing that tells you what will be undone with each delete.

▼ ☑ **Retouch** ✎ ↩ ⚙▾

Stroke: 16 (Delete)

Color and tone adjustments

After you go through the initial adjustments of checking focus, rotating, cropping, removing red eye, and retouching, it's time to turn to the standard adjustment bricks in the Adjustments panel. These adjustment bricks are for making various tone and color adjustments. We'll look at other adjustments in the next chapter, but the defaults provide a great place to start. Let's begin with the White Balance brick at the top of the panel and then work our way down through the rest.

White balance

The White Balance sliders allow you to change the color temperature of an image. This could be necessary because the wrong white balance was selected when the photo was taken, or you want to change it for creative effect. The Temperature slider will make the photo warmer or cooler, and the Tint adjustment will add magenta (to the right) or green (to the left). If you're trying to achieve a neutral image, then you should adjust both of these sliders to remove unwanted color casts.

Quickly compare your adjusted photo to the Master image by pressing the M key. The Master image is your untouched photo, no adjustments applied. Press M again to switch back to the adjusted version.

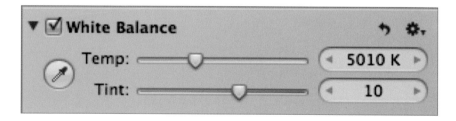

You can also use the eyedropper, which is found in the White Balance brick. Click on the Eyedropper icon, and your mouse pointer changes to an eyedropper and the Loupe appears showing

a portion of the image at 100%. Inside the Loupe is a crosshair, which shows you exactly where the eyedropper is pointing. Along the top edge of the Loupe, it helpfully reminds you to "Choose

Cooler version

Warmer version

Neutral Gray." Click on a neutral gray in your photos, and the Temp and Tint sliders are automatically adjusted to produce a neutral image. Clicking on white sometimes works as well if you can't locate a neutral gray.

If you don't have an obvious neutral gray or white in an image, it can be tough to know where to click with the eyedropper. You end up clicking on a lot of areas, which is tedious because you have to click on the eyedropper in the brick each time. There's a much easier way to do it!

1. Click the eyedropper so that the Loupe appears, but don't click on the image yet.

2. Hold down the Shift key.

3. Click and drag, moving the eyedropper across the photo. You'll see the White Balance of the image automatically change as you move the eyedropper.

4. When you find the spot that produces the White Balance you want, let go of the Shift key and then release the mouse button. The White Balance is changed without tons of clicking!

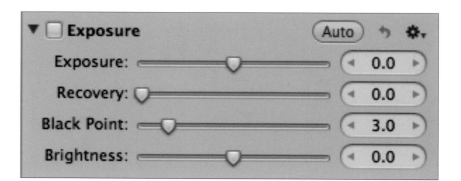

The Exposure brick contains four settings: Exposure, Recovery, Black Point, and Brightness.

Exposure

Take a look at your picture as a whole. Is it too light? Too dark? Just right? Use your eyes first to decide whether it would help to increase or decrease the exposure. The Exposure slider affects all tones: highlights, light tones, midtones, dark tones, and shadows. Make initial

adjustments to the Exposure slider based on what looks good to your eyes.

Aperture also offers visual aids to help you decide whether you should increase or decrease exposure. Let's take a look at the histogram. What you want to avoid in a histogram is losing information in the highlights or shadows (called *clipping*). This is shown by the lack of a gap at either end of the histogram. When there is no gap, you'll see one or more colors flush against the left or right side of the histogram. Think of the sides of the histogram box as walls. When the histogram hits these walls, it goes flat and climbs the wall. That's when you're losing highlight and/or shadow detail.

A histogram without a gap on the right tells you some detail has been lost in the highlights (the brightest areas of the image).

A histogram without a gap on the left tells you some detail has been lost in the shadows (the darkest areas of the image).

While the position of the histogram is useful, it doesn't tell you which areas of your photo have lost highlight or shadow detail. To receive better visual feedback, go to the View menu and choose

Highlight Hot & Cold Areas. This will turn on color overlays to warn you about areas of your photos that are over- or underexposed. Select this option again in the View menu to turn off the warnings.

Not all images will show the red or blue warnings (double-check the hot and cold warnings are turned on!). And that's a good thing. No warnings means the entire range of tonalities

Overexposed areas (losing detail in highlights) are marked with red.

Underexposed areas (losing detail in shadows) are marked with blue.

(shadows to highlights) was captured in your exposure.

If you move the Exposure slider (especially to the extremes), you'll see the amount of red and blue increase or decrease. Adjust the Exposure slider to achieve the

best overall exposure. This means you should not severely darken the photo just to get rid of all the red areas and not overly lighten to remove all the blue. Aim for a balance, which may mean you still have some of those red and/ or blue warnings. No worries

about any lingering warnings; we'll take care of them when we get to the Recovery, Highlights, and Shadows sliders.

Recovery

The Recovery slider allows you to increase the dynamic range of your photographs. As with all adjustments, you'll have the best results by starting with a good exposure. You can then go on to make the image even better. The Recovery slider will bring back a certain amount of detail in areas where highlight information is clipped (areas that the high-light warning turns red). If there are places that are pure white because they have lost all detail, Aperture can't bring back detail because there wasn't any there to begin with.

After moving the Exposure slider to obtain the best overall expo-sure, see whether the Highlight Hot & Cold Areas turns any areas red. If so, move the Recovery slider until the red is gone. You should move the slider just far enough to remove all red warn-ing areas. If you continue to move the slider to the right, it will progressively darken more light tones.

Clipped highlight details are marked by the red areas.

The Recovery slider was adjusted to bring back detail in the highlights.

Black point

Most photos benefit from having the darkest tone in the picture close to black. After making any adjustments to the Exposure overall, I set my Black Point. The default setting for Black Point is 3.00. Here are a couple of considerations before moving the slider:

- Has the shadow warning overlaid any areas of the photo in blue? If so, you will either want to leave the slider alone or move it to the left to try to reduce the blue areas. If you move the black slider to the right, the area of blue will increase, meaning more of your photo is pure black. This can be done for creative effect, but generally you don't want a lot of your photo to be pure black.

- If there aren't any shadow warnings, how do the darkest areas look to your eye? Do they look overly dark and heavy? If this is the case, try moving the slider to the left. It only goes down to zero, so move it slowly to see how the shadows change.

If neither of the preceding tips applies, then moving the Black Point slider to the right will likely improve the photo.

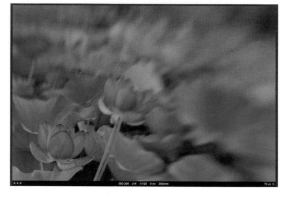

1 Assess the image. There are no shadow warnings, and the image looks a little dull. A black point adjustment will help improve the tones and give the image a richer appearance.

2 Hold down the Command key while moving the slider. Your photo will turn white and then some color(s) will start to appear, and if you move the slider far enough, you'll see areas of black. You'll want to stop somewhere between the first signs of color and the first blacks. The colors indicate that those areas of your photo are becoming dark; if black shows up, it means those areas are pure black in the photo.

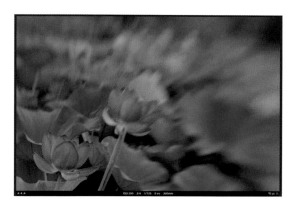

3 Release the Command key to see what your photo looks like. The dark tones of your image should now look richer. You don't have to hold down the Command key while moving the slider; you can simply move the slider and stop when the photo looks good to your eye. Using the Command key just gives you more specific information about how the Black Point adjustment is affecting your photo.

Brightness

The Brightness slider also lightens or darkens a photo, but it mostly affects the midtones. It does not significantly affect the highlight and shadow areas. As a result, Brightness adjustments won't clip detail in the shadows or highlights. When you brighten a photo, be careful not to go too far; otherwise, the image can end up becoming washed out. Alternatively, if your photo started out a little washed out, or "flat," try reducing the brightness a small amount (–0.1 to –0.2); it can make the midtones richer.

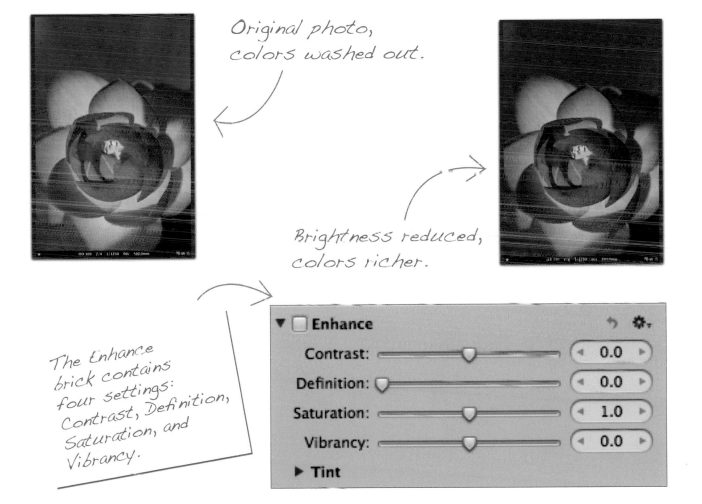

Original photo, colors washed out.

Brightness reduced, colors richer.

The Enhance brick contains four settings: Contrast, Definition, Saturation, and Vibrancy.

Contrast

Contrast can be used to add more "punch" to your images. RAW files in particular often look flat and dull initially and will definitely benefit from a Contrast increase. A little bit can go a long way; even a setting of 0.1 can be enough for some photos. Of course, the result depends on the image, but going too high can create an unnatural appearance.

Nature photography subjects such as landscapes and flowers can use higher amounts of contrast than photographs of people.

Original photo, no contrast.

Contrast increased to 0.15.

Definition

Definition is a localized version of contrast. It adds contrast and sharpening to the details of your photo. Increasing the Definition (default is zero) can help fine details pop, as well as emphasize texture.

Original photo, no definition.

When the Definition is increased, the detail in the door is more apparent. By comparison, the original photo looks a bit flat.

Saturation

Saturation controls the intensity of the colors in your images. This is another setting where a little goes a long way. Don't overdo the Saturation if you want your photos to look natural— especially for people. Vibrancy is a better adjustment for photos of people; we'll look at that next.

Original photo, no saturation

Saturation increased to 1.30.

Vibrancy

The Vibrancy control is a great complement to Saturation. Adjusting Vibrancy is subtler than adding Saturation because it does not intensify all colors equally. If a color is already very intense (a sunset, for instance), Vibrancy will not further increase the intensity. It's also a good choice when you have people in your pictures because Vibrancy does not increase the intensity of skin tones. This next series of photos illustrates which colors Vibrancy does and does **not** affect.

No Vibrancy (no saturation either)

Vibrancy increased to 0.30; notice that the color of the shirt and background are more intense, but the skin tones still look great.

To show what Vibrancy is (and isn't) doing, the slider is moved all the way to the left (–1.00). All the colors except for the skin tones have been desaturated.

Desaturating using Vibrancy can also be used as a creative effect.

Levels

The Levels brick has three main sliders below the histogram. From left to right, there is a black slider, a middle tone slider (also called *gamma*), and a white slider. The sliders always begin in the same positions. The black and white sliders can be moved inward, toward the center. The middle tone slider can be moved left or right.

A common Levels adjustment is to move the black and white sliders until they are touching the ends of the histogram. How much the sliders need to be moved depends on the individual histogram because the shape of a histogram can vary significantly.

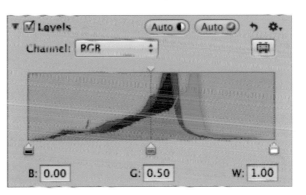

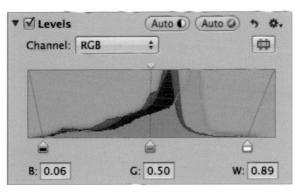

G: 0.55

No Levels adjustment ↗

After Levels adjustment ↗

Moving the black slider has a similar effect to moving the Black Point slider in the Exposure brick. It pushes the darkest areas of the photo toward black. If you've already adjusted the Black Point slider, then there's no need to move the black Levels slider.

The white slider pushes the lightest areas toward white. If you used the Recovery slider in the Exposure brick, then there's no need to move the white slider; you would just be undoing the work of the Recovery adjustment. However, if you turn on Highlight Hot & Cold Areas and nothing shows up red, you'll also want to move the white slider until a

little of the red warning begins to show up. Most photos benefit from having the lightest tone be close to white.

The middle slider lightens or darkens the midtones of the image. Drag the slider to the right to darken the midtones or to the left to lighten them. This adjustment is similar to using the Brightness slider in the Exposure brick, but not exactly the same. Although both adjustments target the midtones, Brightness tends to affect the dark tones a little more than the middle Levels slider. It's not a good or bad thing, just a subtle difference in the results.

Of the three sliders in Levels, the white slider is the only one that accomplishes something you can't do with any of the other adjustment bricks discussed.

Highlights & Shadows

The Highlights & Shadows brick enables you to target the darkest or lightest areas of your photos. Drag the Highlights slider to darken the light tones in your image. Moving the Shadows slider will lighten the darkest parts of the photo.

I often use the Highlights slider in conjunction with the Recovery slider in the Exposure brick. I use the Recovery adjustment first and then turn to the Highlights slider if Highlight Hot & Cold Areas still shows red overexposure warnings. Slowly move the slider until all or most of the red warning areas go away. Don't overdo darkening the highlights; otherwise, they

can become dull. If the Hot & Cold Areas show patches of blue warnings, lightening the dark areas with the Shadows slider will reduce the blue areas. While the Shadows slider can help reveal what is in the darkest areas of your photos, be careful how much you move this slider because the dark areas can become too light, turning washed out.

No adjustment.

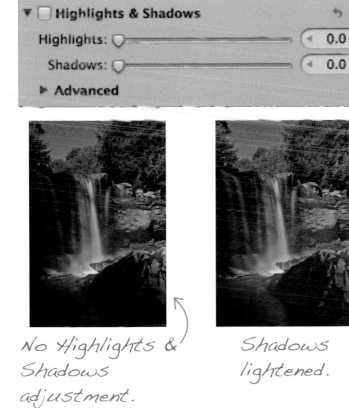

No Highlights & Shadows adjustment.

Shadows lightened.

Highlights darkened, bringing out the subtle detail in the white petals.

Bringing back detail in white

For photos that have a large very light area, such as snow or a textured white wall, it can be difficult to get good detail to show up. For example, you may not have technically lost detail in the snow (no red warnings), but the snow looks like a mass of white without any detail. Here's a trick using Highlights & Shadows plus Levels to bring back the subtle detail:

1. Begin by using the Highlights slider to overly darken the highlights. Try setting the slider between 20 and 30. The white area will look dingy and dull, but you should be able to see better detail in it.

2. To restore the brightness to the highlights, go to the Levels brick. Turn on Highlight Hot & Cold Areas. Move the white slider until red highlight warnings appear on your image.

3. The highlights should now be brightened while still retaining detail and texture. If the highlights remain too dark or dull, go back to Highlights & Shadows and reduce the Highlights adjustment. Then tweak the white slider in Levels if this caused any more red warning areas to appear.

Snow too bright; detail not visible.

Highlights and Levels adjustments applied.

Color

The Color brick is for targeting individual colors in your photos. If you have a purple flower and want to increase the saturation only of the flower, you can use the Color brick to do it. Click on the color square for the color you want to adjust. Then move the sliders to apply targeted adjustments to that color. Adjustments to the selected color will affect that color anywhere in the image. For instance, it your

photo has a blue house and a blue sky, an adjustment to the Blues will affect both.

- **Hue:** Shifts what the color is. Look at the color scale in the Hue slider bar to see how the color will shift. For example, the red Hue slider shows it will shift the reds toward yellow or magenta depending on which way you move the slider.

- **Saturation:** Increases or decreases the intensity of the color.

- **Luminance:** Lightens or darkens the color.

- **Range:** Determines how much of a color is affected. Let's say you select blue. If you move the Range slider to the left, any of the preceding adjustments will affect a narrower range of the blues in the photo. Moving the slider to right will cause a greater amount of the blues to be changed.

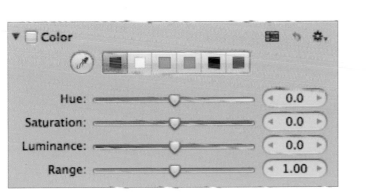

No targeted color adjustments.

Blues adjusted: Saturation increased, Luminance decreased, and Range increased.

You can work with any or all of the six colors. The positions of the sliders are the settings for the selected color. If you've moved the sliders for multiple colors, click on the different colors to see where the sliders are positioned.

If you want to see the sliders for all six colors at once, click the grid icon in the top right of the Color brick. The brick will expand, and each color and its sliders will have a separate section in the Adjustments panel. This makes it easy to see all the colors at once but takes up a lot of space.

DESATURATION TIP

Sometimes it's difficult to know exactly what will be affected by adjusting a specific color. To quickly preview what will change, drag the color's Saturation slider all the way to the left. This will desaturate all the color throughout the photo, making it easy to spot what areas are targeted by that color. Set the Saturation slider back to zero and go about making your adjustments.

FIX BLUE SKIES

A washed-out blue sky may be improved by selecting Blue and then reducing the Luminance and increasing the Saturation. Similar adjustments to Aqua may help out as well.

BRING BACK GREEN FOLIAGE

Have a photo where the greens (leaves, grass) look too yellow? Select Yellow and then set the Hue slider to between 5 and 10.

Choosing your own color

If you want to adjust a color that's not in one of the default colors, you can use the eyedropper to pick a color from your photo. Click on the eyedropper in the Color brick. When the Loupe appears, your mouse turns into an eyedropper. In the Loupe is a crosshair that shows you what you're pointing at with the eyedropper. The color box next to the crosshair shows the color of what you're pointing at. Now find the color you want in the photo and click on it with the eyedropper.

Conclusion

We've come to the end of the initial editing options and default adjustment bricks. For many photos, adjusting these settings may be all you need to do because there is such a variety in the adjustments covered so far. In the next chapter, we'll look at additional tools and adjustments that allow you to make more targeted or selective adjustments to your photos.

There can be only six colors, which means every time you choose a color with the eyedropper, it replaces one of the existing colors. The color chosen with the eyedropper will replace whichever color box was selected at that time. Be careful you don't accidentally replace a color that you want to adjust in your image.

Chapter 5: Image Adjustments:
Beyond the Basics

IF YOU'VE WORKED through the default adjustments bricks and you're looking for even greater control when enhancing your photographs, Aperture has additional adjustments, tools, and features that you'll find useful. In this chapter we'll look at the following adjustments: Black & White, Devignette, Noise

Reduction, Chromatic Aberration, and Sharpening. Plus, we'll find out how to use brushes for selective adjustments. To wrap up features related to image adjustments, this chapter also includes information on Versions, Adjustment Presets, Lift and Stamp, External Editors, and Plug-ins.

Black & white

Converting your photo to black and white is another option available through the Adjustments panel. Select Black & White from the Adjustments pop-up menu at the top of the Adjustments panel, or go to Photos>Add Adjustment>Black and White. The Devignette brick appears in the Adjustments panel.

The Black & White brick has three sliders: Red, Green, and Blue. Where you'll want to position the sliders depends on the individual image. The best thing to do is experiment. The more you use the Black & White brick, the better understanding you'll develop for how the individual sliders will affect a photo. For some colors, there is a direct connection to which sliders affect them. If there is an area in a photo that is clearly red, green, or blue, then moving the matching color slider will lighten or darken that color. For instance, if you have a blue sky, then moving the Blue slider will lighten or darken the sky. If there's a red barn, the Red slider will have the greatest effect on the barn. Move the Green slider to change green foliage. As for other colors in your photos, it is

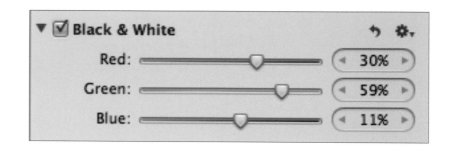

not readily apparent which color slider will affect them, which is why experimentation and practice are key.

Using the sliders in the Black & White brick isn't the only way to adjust your monochrome image. All the other adjustment

bricks can still be used, so feel free to adjust exposure, contrast, definition, and so on. Also, you might be surprised to know that your black-and-white photo can still be affected by adjustments that change colors. This means the White Balance and Color

bricks will have an effect on your photo. How can this be? Hasn't all the color disappeared from the image? Well, even though you're working on an image that is shown in shades of gray, the adjustments are still based on the color information in the original photo. To get the most out of the black-and-white conversion, don't limit yourself to using only the Black & White brick. Experiment with all of them!

Devignette

Devignette is for removing vignetting from your images. *Vignetting* is a darkening in the corners of an image. The design of some lenses produces vignetting at certain settings. Vignetting can also be caused by a thick filter on a wide angle lens. The Devignette adjustment aims to lighten these darkened corners to reverse the effect.

The Intensity slider controls the strength of the devignetting effect (how much the corners are lightened). The Radius slider controls how far the lightening effect extends into the photo. A low Radius setting targets just the corners with the lightening effect. The larger the Radius, the more the lightening reaches in toward the center of the image. Adjust both sliders to find the right balance to remove the vignetting.

Select Devignette from the Adjustments pop-up menu at the top of the Adjustments panel, or go to Photos>Add Adjustment>Devignette The Devignette brick appears in the Adjustments panel.

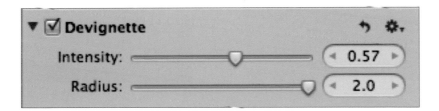

Be aware that if there is particularly heavy vignetting, as seen in the thistle photo, it may not be possible to remove all the vignetting without adversely affecting the rest of the photo. In that case, fix as much as you can with Devignette and then use the Crop tool to trim off the remaining dark corners. Of course, you could just crop off the vignetted areas in the first place, but by using Devignette, you'll reduce how much you need to crop.

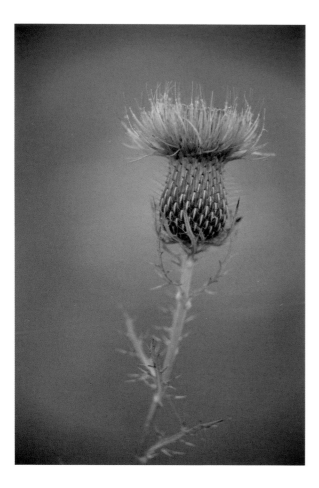
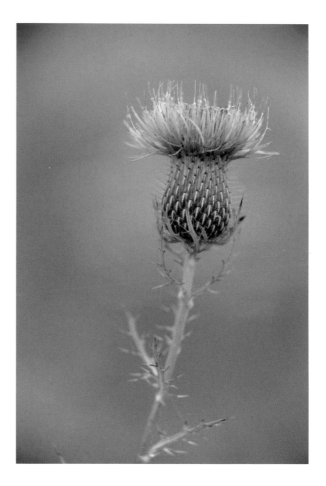

Noise reduction

Photographs taken at a high ISO setting may have unsightly noise that you want to get rid of. Noise can obscure fine details and is often more noticeable in the shadow areas of a photo. It may also create a textured or mottled appearance in areas of smooth tonality, such as clear blue skies. Unless the noise is really bad, you're not likely to see the problems it creates if you're looking at the whole image. Zoom in (press the Z key) to accurately assess if there is problematic noise in the photo. What you're looking for is a fuzzy or grainy appearance.

The Noise Reduction adjustment is available in the Adjustments pop-up menu at the top of the Adjustments panel, or go to Photos>Add Adjustment>Noise Reduction. The Noise Reduction brick appears in the Adjustments panel.

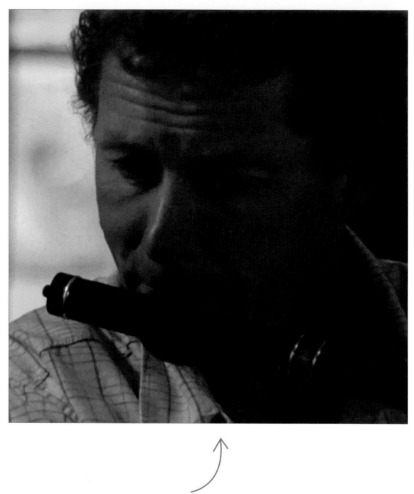

There is noise on right side of the musician's face (shadowed area).

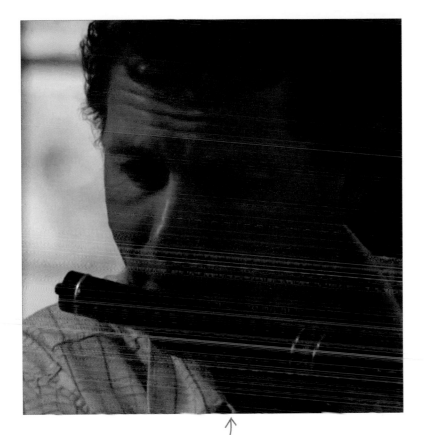

Here's a test to see what noise looks like and find out how your camera performs at high ISOs. Take a photograph of the same object at each ISO setting (100, 200, 400, 800, and so on). Then examine the photos in Aperture; look in the Metadata panel to find the ISO setting for each photo. Zoom in using the Z key to check out the details. Compare the photo taken at the lowest ISO with the one shot at the highest ISO. The high ISO photo will have lots of noise, making it easy to see what noise looks like. Then look at the photos taken at the other ISOs to determine at what ISOs noise becomes a problem for your camera.

Using Noise Reduction has improved the appearance of the skin.

Noise reduction is always a balance between decreasing (or eliminating) the noise while retaining detail in the image. There are two sliders in the Noise Reduction brick: Radius and Edge Detail. Radius is the amount of noise reduction being applied. A higher radius minimizes the noise but also softens the image. The Edge Detail slider is used to bring back the detail that is lost with the Radius adjustment. Work with both sliders to find the best balance between reducing noise and retaining detail in your photo.

Chromatic aberration

Chromatic aberration is a colored line that appears along a high-contrast edge, which is where a dark tone meets a much lighter tone. This line, also called *fringing*, will either be red, blue, or yellow. It's something you may not notice when looking at the entire photo. Zoom in to 100% (using the Z key) so you're at full size when looking for, and correcting, chromatic aberration.

Choose which slider to move based on the color of the fringing. You'll want to move the slider that includes the fringing color. For example, if the fringing is blue, then move the slider for Blue/Yellow Fringe. Drag the slider until the fringing is gone. For some photos, you might even need to move both sliders.

The Chromatic Aberration adjustment is available in the Adjustments pop-up menu at the top of the Adjustments panel, or go to Photos>Add Adjustment>Chromatic Aberration. The Chromatic Aberration brick appears in the Adjustments panel.

In this photo of a leaf and seed pod, the backlighting was so intense that everything became a silhouette. There is fringing along the high-contrast edges where the silhouette meets the background. However, when you look at the entire photo, it's difficult to see.

2

Let's look at a portion of the photo at 100% to better see the fringing. Notice there's a thin blue outline along the black edge of the leaf.

3

Moving the slider for Blue/Yellow Fringe eliminates the problem.

Sharpening

Sharpening is not for turning out-of-focus photos into sharp photos. Sharpening will enhance a photo that is in focus to start with. When you apply sharpening, you are increasing the contrast along high-contrast edges in the photo—for example, where a dark tone meets a light tone. This additional contrast increases the apparent sharpness of the photo. There are two sharpening adjustments in Aperture: Sharpen and Edge Sharpen. You definitely should go with Edge Sharpen. It offers greater control and higher quality results. I recommend completely ignoring Sharpen.

Although sharpening is a good thing, be careful to avoid over-sharpening, which is not attractive at all. When a photo is oversharpened, the high-contrast edges have a thin glowing outline that is called a *halo*. The photo also has a very "crispy" or "brittle" look, with everything being too well defined. To get a feel for what oversharpening looks like, increase all three sliders in the Edge Sharpen brick to very high values.

For sharpening, there isn't one set of numbers I can tell you to always use. Sharpening is half art, half science. I'll offer some guidelines, but the final decision will come down to how the photo looks to your eyes. As you sharpen more photos, experience will also teach you how to choose the right amount of sharpening.

The Edge Sharpen adjustment is available in the Adjustments pop-up menu at the top of the Adjustments panel, or go to Photos>Add Adjustment>Edge Sharpen. The Edge Sharpen brick appears in the Adjustments panel.

Maximum Edge Sharpen settings.

Unsharpened image.

SUGGESTED SHARPENING VALUES

Here are the values that I find offer a good starting point. You can then adjust the sliders to find the right balance for the image. Always remember to view your photo at 100% when assessing the effect of the sharpening.

- **Intensity:** 0.65 to 0.75
- **Edges:** 0.35 to 0.45
- **Falloff:** 0.20 to 0.30

The Intensity slider controls the overall amount of sharpening. The Edges slider determines what is considered an "edge" in your photo. The higher the value, the more defined the edges in your photo become. The Edges adjustment often has a more noticeable effect on your photo than the Intensity adjustment.

The name of the Falloff slider may suggest that it will cause the amount of sharpening to be reduced, or "fall off," However, it actually does increase sharpening. What's going on behind the scenes with Edge Sharpen is that Aperture applies three stages (or passes) of sharpening. The Falloff adjustment controls the amount of sharpening applied at the second and third stages. I find it more of a fine-tuning adjustment compared to Intensity and Edges. The higher the value of the Edges slider, the greater change you'll see when adjusting the Falloff slider.

Versions

When you're working with your photos, sometimes it would be convenient to have multiple variations of the same image. Perhaps you'd like one version in color and another in black and white. Or maybe a variation in White Balance: one warmer and one cooler. If you want do this, there's no need to actually copy a file; all you have to do is use Aperture's Versions feature.

Select the photo for which you want another version; then go to Photos>Duplicate Version. Aperture will create an identical version and stack it with the original photo. This duplicate version has all the same image adjustments and metadata (including IPTC and keywords) as the original.

You can then work with the duplicate version just like the original; all of Aperture's tools are available to you. You can create many versions if you like. When a new version is created, Aperture does not duplicate the image file; it just makes a separate list of the adjustments and metadata that go with the variation. So don't worry about these versions taking up a lot of space on your hard drive; the added size is minimal.

The other Version option in the Photos menu is New Version from Master. The version created with this option is a duplicate of what your photo looked like when you first brought it into Aperture before any adjustments were made or metadata added. This option gives you a clean slate to work from, whereas Duplicate Version is better for building on or adjusting previous settings.

Hilz_060408_0223 Hilz_060408_0223 - Version 2

Brushes

Although the Highlights & Shadows and Color bricks offer ways to target particular tones and colors, they can't match the capabilities of Aperture's Brush feature. Let's say you have a photo that includes a blue house and blue sky. You want to make the house lighter. If you use the Color brick to lighten the blues, the change will affect both the house and sky. By using a brush, you can get the results you want because you're able to selectively apply various adjustments. Here's another example: There are two orange flowers in a photo, and you want to increase the saturation of one of the flowers. Using a brush is the only way you can increase the saturation of just one of the flowers. Aperture offers two ways to work with the Brush feature: Quick Brushes and brushes associated with the Adjustments panel bricks. Either way, the concept is the same: You use a brush to control what areas of a photo are affected by a particular effect or adjustment.

Quick brushes

Aperture has a list of ready-to-go brush options called Quick Brushes that you can find in the Adjustments pop-up menu at the top of the Adjustments panel. Or go to Photos>Add Adjustment>Quick Brushes.

After you select a Quick Brush, a brick for that brush appears in the Adjustments panel.

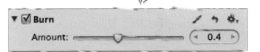

A Brush HUD floats over the Aperture window that contains the brush options.

Before we go into the specifics of what each Quick Brush does, let's first learn about the basics of using brushes. For the following examples, I'll use the Burn brush (for selective darkening), but the options discussed are the same for any of the brushes.

Using the brush is pretty easy: When you move the mouse pointer over your photo, the pointer turns into a circle that represents the brush. To apply the effect of the selected brush, click and drag the brush over the areas of the photo you want to change.

The Brush HUD has the three sliders: Size, Softness, and Strength.

- **Brush size:** This slider determines how large the brush circle is. Choose the size of the brush based on how large the area is that you want to change. Choose a big brush for large areas to save time or use a small brush when doing detail work. If you have a mouse with a scroll wheel, you can change the size of the brush by turning the wheel when the brush is over the photo. If you're using a laptop, you can do this by placing two fingers on the trackpad and sliding them up or down. This technique is faster than using the slider, and you don't have to move your brush.

- **Softness:** You'll notice the brush has an inner circle and an outer circle. The amount of space between these circles is controlled by the Softness slider. The larger the Softness setting, the softer the brush. A softer brush makes it easier to blend in your effect with the surrounding area. If the brush has little or no softness, then the applied effect can be very obvious, having an unnatural "stamped on" appearance. I usually use a Softness amount between 0.50 and 1.00.

- **Strength:** This slider determines the strength of the effect of the Quick Brush. Move the slider all the way to the right (1.00) for full strength. You can change the strength as you work on your photo, which gives you the ability to apply varying levels of the effect across your image.

Detect edges

The Detect Edges option makes it easier to target the area you want to change and not affect what's next to it. Check the box next to Detect Edges to turn it on. It's particularly useful when you are applying an effect close to the edge of an object. For example, say you're darkening an area of sky that's next to a building. By using Detect Edges, you can apply the darkening right up to the edge of the building, without affecting the building.

The key to using Detect Edges effectively is the plus sign in the middle of the brush. To know what the brush is going to affect, don't pay attention to the entire brush, just the plus sign. The color that the plus sign is touching is the color that will be affected. In the following photo, the Burn brush is touching both the roofline and the sky. However, because the plus sign is over the blue sky, the brush darkens only the sky. The roof is not affected at all.

When you check the box for Detect Edges, the maximum Brush Size is smaller because Detect Edges is meant for detail work, not covering large areas all at once.

At the top of the Brush HUD are three buttons that control the mode of the brush. They are Brush-in, Feather, and Erase. No matter which you're using, you still click and drag on your photo to apply their individual functions.

- **Brush-in:** This is the default mode where you are applying the effect to your photo.

- **Feather:** Sometimes you can end up with an obvious transition between where the effect was applied and where it wasn't. Brush with the Feather mode to create a smoother transition.

- **Erase:** This mode removes the effect of the brush.

Being able to switch between Brush-in, Feather, and Erase offers great flexibility in using the brush. Don't worry if you brush over something by mistake. Just switch to Erase and remove the effect. End up with a transition that's too abrupt? Use Feather to soften the edge.

Additional brush options are found in the Action menu (gear icon) at the top of the Brush HUD.

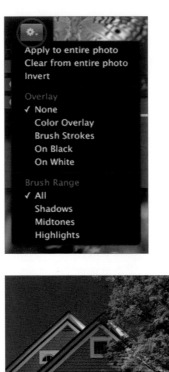

- **Apply to entire photo:** If your intent is to apply the brush effect to most of the photo, start by choosing this option. Then select the Erase mode and remove the effect from the areas where you don't want it.

- **Clear from entire photo:** This option removes all the adjustments made with the brush. It's useful if you've done some work with the brush but then decide you want to start over.

- **Invert:** This option reverses which areas have been changed by the brush and which haven't.

Overlay

The Overlay choices are display options for showing where you've used the brush on your photo. I prefer Color Overlay, which displays a semi-transparent red overlay on areas where the brush has been used. If it's red, it has been changed with the brush; if it's not red, it hasn't. You can still use the brush (Brush-in, Feather, Erase) while the overlay is visible. You'll see the red appear or disappear as you work. This can be helpful visual feedback, making it easier to see exactly what the brush is or is not changing.

Brush range

The Brush Range options offer the ability to target specific tonalities with the effect of the brush (Shadows, Midtones, Highlights). For example, if you choose Shadows and then try to use the brush on a light part of your photo, it won't have any effect. Choosing a particular range is not required, but it does give you a finer degree of control over how the brush's effect is applied.

Finishing up

When you're done with the brush, click the X in the corner of the Brush HUD. If you want to go back and use the brush again, all you have to do is click the Brush icon in the brick.

Quick brush descriptions

As mentioned earlier, each Quick Brush will show up as a brick in the Adjustments panel. For all but one of the brushes, there are one or more sliders in the brick. These sliders are for adjusting the specific effect of the brush, ___ ___ions in the Brush ___ with *how the* ___ apply the effect. ___uick Brushes are ___ you're already ___om the regular ___icks. The only dif- ___ the Quick Brushes selectively apply the adjustment.

- **Skin smoothing:** Use this brush for portraits to create softer skin, blurring wrinkles and minimizing imperfections. The default settings in the Skin Smoothing brick work well. Skin Smoothing will have a lesser effect with a lower Radius setting. The Detail slider controls the level of detail visible after the smoothing is applied. Be careful with the Intensity slider; it's easy to go too far and end up with unnatural results.

- **Dodge (lighten):** This brush lightens areas of your photo. It affects all areas equally (high-lights, midtones, shadows).

- **Burn (darken):** This brush darkens areas of your photo. It also affects all areas equally (highlights, midtones, shadows).

- **Polarize (multiply):** This brush also darkens your photo, but it does not affect all areas equally. Polarize darkens only areas that are midtones and shadows. It does not affect highlights.

- **Intensify contrast (overlay):** As the name suggests, this brush increases contrast, but similar to the Polarize brush, it does not affect all tones equally. This brush adds contrast only to the darker areas of a photo, specifically tones that fall between black and midtone. It's great for improving the appearance of washed-out shadow areas.

- **Tint:** Tint is for changing what color something is. You choose the color by moving the Angle slider. Unfortunately, the Angle number doesn't tell you what color you've selected. Instead of blindly moving the slider, try this: Go to the Action menu (gear icon) in the Tint Brush HUD and choose Apply to Entire Photo. Then move the Tint slider to find the color you want. After you've got the color, go back to the Action menu and choose Clear from Entire Photo. Then go to work with the brush.

- **Contrast, saturation, definition, vibrancy:** These four brushes have the same effect as their counterparts in the Enhance brick.

- **Blur:** Use the brush to selectively blur, or soften, areas of your photo. Control the amount of blur using the slider. This comes in handy if you want to create a selective focus look by blurring the background.

- **Sharpen:** This brush does basic sharpening; it offers just a single slider so you don't have as much control over the results compared to using the Edge Sharpen adjustment.

- **Halo reduction:** This is similar to the Chromatic Aberration adjustment, except that it removes only blue and purple fringing. There is no slider in the Halo Reduction brick.

- **Noise reduction:** This brush has the same sliders as the regular Noise Reduction adjustment.

Using brushes with regular adjustments

The ability to use brushes for selectively applying effects is not limited to the Quick Brushes. Most of the adjustments you use in the Adjustments panel can be selectively added or removed with a brush. To see whether there's a brush option for a particular adjustment, go to the brick's Action menu (gear icon) and look for two brush-related options at the top.

Choose Brush in or Brush away, and the Brush HUD appears. There, you can selectively apply the adjustment. This is the same Brush HUD that's used with the Quick Brushes.

"Brush in" means the adjustment will *not* be applied to any part of the photo. In the Brush HUD, the Brush-in button is selected, and you control where the adjustment is added.

"Brush away" means the adjustment will be applied to the *entire*

photo. In the Brush HUD, the Erase button is selected, and you choose where you want to remove the adjustment from.

Which option is best depends on how you want to apply the adjustment. If you want the adjustment to affect only a small part of the photo, go with Brush in. If the adjustment will affect most of the photo, choose Brush away. Using this approach will create the least amount of work with the brush.

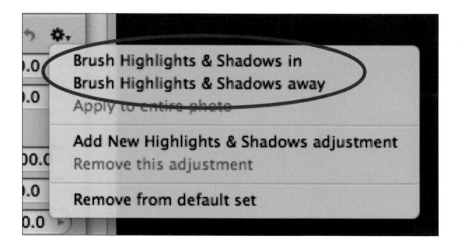

ADD MULTIPLE BRICKS OF THE SAME ADJUSTMENT

You're not always limited to one brick for each adjustment. Some bricks (both Quick Brushes and regular adjustments) allow you to have multiple bricks of the same adjustment. To see whether this is an option, go to the brick's Action menu (gear icon) and look for Add New _____ adjustment. Click this option, and you'll have a whole new brick to work with.

Adjustment presets

Adjustment presets allow you to save a group of settings from the Adjustments panel so you can quickly apply them to other photos. A preset can be a single setting (the Vibrancy adjustment, for instance) or many different settings. For example, I've found a combination of Contrast, Saturation, and Vibrancy that works well for most of my nature photographs. I've saved this group of settings as a preset, which makes it much faster to apply them to any photo I want. I also have a preset that's just an Edge Sharpen adjustment. It gives me a good starting point for my sharpening; then I just have to fine-tune the sliders for the individual image.

If there are settings you find yourself applying repeatedly, save time and effort by making them into an adjustment preset. You can also apply multiple presets to one photograph. Applying additional presets to a photo will not wipe out what the previous presets did—unless the preset uses the same adjustment. You can even choose a preset to apply to your photos right when you import them (see Chapter 1).

To work with adjustment presets, go to the Adjustments Panel. In the top section of the panel is the Presets pop-up menu. Within this menu, you can select as well as create or edit a preset. Aperture comes with a number of presets already installed. As you move your mouse pointer over the various presets, a preview window pops up to show you what the selected photo will look like with the preset applied. To apply a preset, simply click the preset name. Next, we'll walk through how to create a preset.

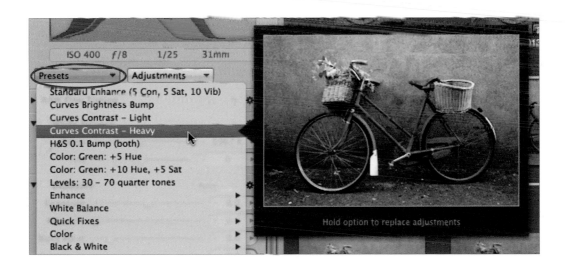

If you hold down the Option key while selecting a preset, it will reset all adjustments to the photo and then apply only the adjustments from the preset.

Before going to the Presets menu, set all the adjustment bricks as you want them to be in the preset. When everything is as you like it, click the Presets menu and then choose Save as Preset at the bottom.

The Adjustment Presets window pops up. Your preset shows up as Untitled Preset from the bottom of the list. Name your preset; then press the Return key.

The right column shows which adjustments are in the preset. It does not tell you the settings of the adjustments. The adjustments go by the name of the adjustments brick they are part of. For instance, if you have a contrast and saturation adjustment in your preset, the column will list Enhance because they're part of the Enhance brick. The same would be true for any adjustment brick that has multiple settings (White Balance, Exposure, Color, and so on).

4

If you want to remove any of the adjustments within a preset, click the minus symbol next to the adjustment name. Click OK when you're done.

Exposure	⊖
Enhance	⊖
Black & White	⊖

The Adjustment Presets Action menu also includes the presets options Delete, Duplicate, and Reset.

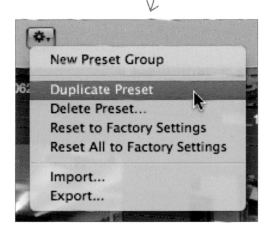

ORGANIZING PRESETS

• To organize presets, first choose Edit Presets from the bottom of the Presets pop-up menu.

• To move a preset, click and drag its name to the place you want it in the list.

• Use groups to further organize your presets. Click the Action menu (gear icon) at the bottom left of the window and choose New Preset Group. Groups have an arrow next to them, To move a preset to the group, click and drag the preset to the group name.

• Click the arrow next to the name of a preset group to show or hide the names of the presets within it.

Exporting and importing presets

Being able to export and import adjustment presets makes it possible for Aperture users to share their presets. Begin by bringing up the Adjustment Presets window (in the Presets pop-up menu, choose Edit Presets at the bottom).

Exporting

1. In the Adjustment Presets window, select the preset(s) you want to export. This can be one or multiple presets, including preset groups.

2. In the Action menu (gear icon), select Export.

3. Choose a name for the preset(s) you're exporting and choose where to save it (or them). Then click OK.

Importing

1. In the Adjustment Presets window, go to the Action menu (gear icon) and select Import.

2. Locate the preset file on your computer that you want to import. Click OK.

3. The imported preset will appear in your list.

Applying presets to multiple photos

To apply a preset to multiple photos, you can't use the Preset button in the Adjustments panel. Even if you have multiple photos selected, the preset will be applied to only the first of the selected images. To apply a preset to all the selected photos, go to the Photos menu; then select Add Adjustment Preset and choose the preset name.

Lift and stamp

The Lift and Stamp tools are used for copying (lifting) adjustments and/or metadata from one photo and applying it (stamping) to other photos. It's an incredibly useful tool that can save you a lot of time when you want a bunch of images to all have the same adjustments and/or metadata.

These tools can be used in a couple of different ways depending on whether you are looking to stamp a few images or lots of images.

I will be focusing on using buttons and keyboard shortcuts for lifting and stamping, but you can also find lift and stamp commands at the bottom of the Metadata menu.

1

Lift and stamp for lots of photos:
Select the photo whose adjustments/metadata you want to copy; then click the Lift tool in the tool strip at the bottom of the Aperture window. The Lift & Stamp HUD appears.

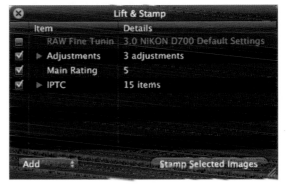

2

Select the photos to which you want to add the adjustments/metadata (this could be 5, 50, 100, or more photos). To stamp the selected photos, click the Stamp tool button or click the Stamp Selected Images button in the Lift & Stamp HUD. Those adjustments/metadata have now been added to all the selected photos.

When you're done lifting and stamping, press the Escape key to close the Lift & Stamp HUD.

1

Lift and stamp for just a few photos:
When you have a small number of photos to stamp, there's a faster method. Begin by pressing the letter O to bring up the Lift & Stamp HUD.

2

Move the mouse pointer over your thumbnails, and you'll see it change to an up arrow. The up arrow means that for whichever photo you click on, the adjustments/metadata will be lifted from that image. The information in the Lift & Stamp HUD will change to reflect this.

Hilz_050715_1570...

3

Hilz_050715_1563.NEF

Now that the information has been "lifted," when you place your mouse pointer over an image, it becomes a down arrow. The down arrow means that when you click on a photo, the lifted adjustments/metadata will be added to it. You can click on as many photos as you want, but with this method, you're always adding the adjustments/metadata to one photo at a time.

Tips for the lift & stamp HUD

- The Lift & Stamp HUD shows the categories of information that you lifted from an image. If there is no information in a particular category, that category won't show up in the HUD. For instance, if a photo doesn't have any IPTC info, then IPTC won't be listed in the HUD.

- In the HUD, you can fine-tune what information will be stamped, making it a versatile tool.

- Each category of information (Rating, Adjustments, IPTC, Keywords, and so on) has a checkmark next to it. Uncheck the boxes for the information you don't want stamped.

- If a category has multiple adjustments/items, it will have a triangle next to it. Click the triangle and see exactly what information will be stamped. When there are multiple items, you can pick and choose what you want to use. If you don't want an item stamped, click on it and then press Delete.

- The Lift & Stamp HUD also has a "memory," which I find convenient. If you uncheck a category, the next time you bring up Lift & Stamp, that category will still be unchecked. For example, let's say you uncheck Rating because you don't want the rating passed on. You can go ahead and stamp the other info and return to editing your photos. The next time you bring up the Lift & Stamp HUD, you'll see that Rating is still unchecked. I find this feature useful because many times I don't want to pass on a rating or metadata, only the adjustments.

In the Lift & Stamp HUD, to change the width of the item column, place your mouse on the vertical line separating the Item and Details headings; then click and drag left or right.

Add/Replace options for lift & stamp

At the bottom of the Lift & Stamp HUD is a menu where you can choose either Add or Replace. This choice matters only when you're stamping adjustments or keywords. Let's look at the differences between these options.

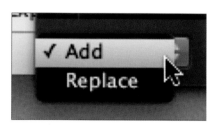

Keywords

- *Add:* The lifted keywords will be added to any existing keywords in the stamped photos.

- *Replace:* The lifted keywords will replace any keywords that already exist for the stamped photos.

Adjustments

- *Add:* The lifted adjustments are the only things that will change for the stamped photos. To put it another way, bricks in the stamped photos will not change unless they're in the lifted adjustments.

- *Replace:* The adjustment bricks of the stamped photo will be

changed to match the bricks from whichever photo you lifted the adjustments. This can result in bricks being removed or reset in the stamped photos. Let's say the lifted adjustments are in the Exposure and Enhance bricks. If you choose Replace and then stamp a photo that has a Crop adjustment, the crop will be removed and the Exposure and Enhance bricks will be changed. Or if the stamped photo originally had a Highlights & Shadows adjustment, that brick will be reset to the defaults (it won't be removed because it's one of the default bricks). This replacement behavior makes the bricks on the lifted and stamped photos exactly the same.

External editor

As you've seen in this chapter and in Chapter 4, you can accomplish a lot with the options Aperture offers for adjusting your photos. Even so, there may be times when you just can't do everything you want in Aperture. When you need to go beyond Aperture's built-in capabilities, you can use an external editor or a plug-in.

Using an external editor means leaving Aperture and adjusting your photo using another application. The process of leaving Aperture, working in another application, and then returning to Aperture is well integrated and goes smoothly. Before using an external editor, however, you'll need to set up your External Editor Preferences. Go to Aperture's Preferences (Aperture> Preferences); then select the Export section.

The first three settings in the Export section are for the External Photo Editor:

- **Photo Editor:** This setting determines the other application you want to use, such as Photoshop or Photoshop Elements. Click the Choose button and then locate the application on your computer.

- **File format:** When you go to the external editor, Aperture makes a copy of the photo for you to work on. Here, you choose the file format for the copy. I prefer 16-bit TIFF. I choose 16-bit over 8-bit because it means the file will contain more information. Photoshop supports 16- or 8-bit; Photoshop Elements supports only 8-bit.

- **Color space:** Here, you can select Adobe RGB 1998 or ProPhoto RGB. I prefer ProPhoto because it is a larger color space than Adobe RGB, which means it has more color information.

To send a photo to the external editor, select the photo and then go to Photos>Edit with _____ (name of the application you selected). Aperture makes a copy of the photo based on the Export preferences and opens the copy in the external editor. After working on the photo in the external editor, be sure to save it (File>Save); then close the photo and go back to Aperture. Back in the Browser view, there is a stack of two photos: the original and

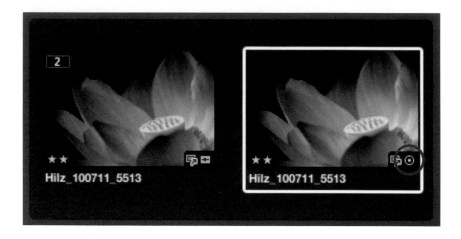

the one adjusted in the external editor. If you have Badges displayed in the Metadata Overlays (see Chapter 2), the photo from the external editor will be marked by a circle with a white dot inside.

You can also return to the external editor to do more work on the photo. All you need to do is select the photo (the one previously worked on in the external editor) and then go

to Photos>Edit with _____ (the name of the editor). The photo will reopen in the external editor, and you can continue adjusting the photo.

After you edit a photo in the external editor, you can still use the Adjustments panel to further enhance the photo.

Plug-ins

Sometimes you may not actually need to leave Aperture for an external editor. Plug-ins are software add-ons that you access from within Aperture. They're made by companies other than Apple, and they generally offer access to features or functions not available in Aperture. There are numerous plug-ins available that offer many additional functions. The majority of plug-ins are related to image editing, but there are also others that offer added functionality for tasks such as exporting photos and designing books. To see a sampling of plug-ins available, visit the Aperture Plug-ins page on the Apple website: www.upplo.com/aperture/resources/plugins.html.

After installing a plug-in, you access it though the Photos menu. Select the photo(s) you want to use with the plug-in; then go to Photos > Edit with Plug-in and choose from the list of the installed plug-ins.

Edit with Adobe Photoshop CS5...	⇧⌘O	
Edit with Plug-in	►	BorderFX...
Remove from Album	⌫	Color Efex Pro 3.0 Complete (32-bit)...
		Dfine 2.0 (32-bit)...
Duplicate Version	⌥V	HDR Efex Pro...
New Version from Master	⌥G	Photomatix HDR Tone Mapping (32-bit)...
New JPEG from Frame		Sharpener Pro 3.0 (1): RAW Presharpener (32-bit)...
		Sharpener Pro 3.0 (2): Output Sharpener (32-bit)...
Set RAW as Master		Silver Efex Pro (32-bit)...
Set JPEG as Master		Viveza 2...

After you choose a plug-in, a new window will pop up with the controls and settings for that plug-in. When you're using an image editing plug-in, Aperture first makes a copy of the photo for the plug-in to use (just like what's done when using an external editor). Plug-ins are not applied directly to your original photo (RAW or JPEG). The type of file Aperture creates for the plug-in to use is controlled by the external editor settings in the Preferences (Aperture>Preferences, Export section).

After you finish working with the plug-in and return to the regular Aperture interface, what you see is the same as when returning from an external editor. There is now a stack of two photos in the Browser view: the original and the one adjusted with the plug-in. The photo edited with the plug-in is marked the same way as those edited with an external editor: a badge that's a circle with a white dot inside.

Conclusion

At this point, you've worked on your images using both basic and advanced image adjustments, and they're looking good! Now that you've applied global adjustments plus done some selective fine-tuning, you've come to the end of adjusting and enhancing your photographs. The next steps in your photographic workflow will be adding metadata and then deciding what you want to do with your photographs: How do you want to share them and get them out in the world? The next chapter will focus on metadata and keywords. The later chapters will look at what you can create in Aperture to share your images.

Chapter 6: Metadata and Keywords

THE METADATA FEATURES of Aperture are
important tools that help you find your
photos as well as keep them organized.
If you have just a few hundred photos,
scrolling through all of them to find
the ones you're looking for may not be
a big deal. However, when you have
thousands or tens of thousands of
photos, scrolling through thumbnails
becomes time consuming and tedious.
That's where metadata comes in. Meta-
data is information that is tied to your
photos. Some metadata shows up auto-
matically; other metadata you have to
add. Whichever type it is, you can search
for it later. And this ability to search for
metadata is what will make your life
easier. Metadata and the Metadata
panel were introduced in Chapter 1; in
this chapter we'll explore these features
in depth. First, we'll look at how to view
the available metadata and then find out
how to add our own metadata.

The Metadata panel gives you access to
both EXIF and IPTC metadata. You can

EXIF AND IPTC METADATA

- **EXIF:** Metadata that your camera adds
 when your camera takes a picture; it's
 info that is specifically about that photo
 (camera model, aperture, shutter speed,
 focal length, lens, and so on). You
 cannot edit or change this information.
 EXIF stands for Exchangeable Image File
 Format.

- **IPTC:** Metadata that you choose to add
 (keywords, copyright, caption, location,
 city, state, country, and so on).
 IPTC stands for International Press
 Telecommunications Council.

use the panel to view, add, or change
metadata. The information shown in the
panel is for whichever photo is selected.
At the top of the Metadata panel is the
Camera Info section. In this section
you can see key camera settings and
equipment information at a glance.
Directly below this info, you can see
whether the photo is labeled, rated,
or flagged (you can also change these
three settings here).

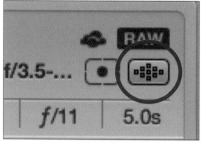

If you don't want to see the Camera Info section, click the gear icon below that section and choose Hide Camera Info from the bottom of the pop-up menu.

Among all the numbers and symbols packed in the Camera Info section, there is a not-so-obvious option: You can see where the camera focused. The box on the far right, directly above the shutter speed, represents the focusing boxes. If you click this box (or hover your mouse pointer over it), it lights up red, and the focusing boxes from your camera are overlaid on the photo. If autofocus was engaged when you took the photo, the focusing box that was used will be red (unused focusing boxes are white).

Metadata views

Most of the rest of the Metadata panel is reserved for different displays of metadata. Various metadata groupings can be found in the pop-up menu below the exposure information section.

These are called *Metadata views*, and they're sets of metadata information. Aperture comes with a bunch of preset views that can be easily edited or deleted; plus, you can create new views. Take advantage of the various views while working with your photos. Which view you want to use will depend on where you are in the editing process. Over time you'll have a better idea which metadata is useful for you to see and which isn't. This will guide you in making decisions about editing (or deleting) the views, as well as creating your own.

EXIF Info	
Version Name:	Hilz_090613_2528
Date:	6/13/09 3:30:15 PM EDT
Camera Make:	NIKON CORPORATION
Camera Model:	NIKON D200
Pixel Size:	3872 × 2592 (10.0 MP)
Aperture:	f/4
Shutter Speed:	1/125
Exposure Bias:	0 ev
Focal Length (35mm):	78.0mm
Focal Length:	52mm
ISO:	ISO 200
Aspect Ratio:	3:2
Orientation:	Landscape
Depth:	16
Color Space:	
Exposure Mode:	Manual Exposure
Flash Exposure Co...:	0 ev
Flash:	Strobe return light not detected
Serial Number:	
Lens Minimum (mm):	35.0mm
Max. Lens Aperture:	3.0
Lens Maximum (mm):	70.0mm
Lens:	AF Zoom-Nikkor 35-70mm f/2.8D
Color Model:	RGB
Profile Name:	Adobe RGB (1998)
Badges:	
Nikon Focus Mode:	AF-S
Nikon White Balanc...:	AUTO
Nikon Flash Setting:	NORMAL
Nikon Quality:	RAW

To get a better idea of what
EXIF information is versus IPTC
information, look at the following
views: EXIF Info and IPTC Core.
In the EXIF Info view, you'll see
more details about your camera
settings than you may ever want
to know! IPTC Core has four
categories (Contact, Content,
Image, Status) each with a set
of fields. These fields are always
blank to begin with, and you can
add information to them.

To create or edit a Metadata
view, click on the Metadata View
pop-up menu and choose Edit at
the bottom.

Choosing this option brings up
the Metadata Views window. The
left column lists the existing views,
and the right column shows what
fields have been chosen for the
selected Metadata view. Checked
boxes mean those fields will be
shown for that Metadata view.

Metadata Views

Metadata Views	Metadata Fields
Metadata Overview	▼ EXIF
Location Preset	☐ Altitude
Basic Info	☑ Aperture
Location Info	☐ Artist
Caption & Keywords	☐ Brightness
Viewer – Custom	☑ Camera Make
For Browser List View	☑ Camera Model
File Extension for Browser Regular View	☑ Color Model
Contact Sheet Info	☑ Color Space
EXIF Info	☐ Contrast
General	☐ Copyright
Name Only	☑ Date
Caption Only	☑ Depth
Name & Ratings	☐ EXIF Version
Name & Caption	☑ Exposure Bias
Ratings	☑ Exposure Mode
Caption & Credits	☐ Exposure Program
File Info	☐ Firmware
Photo Info	☑ Flash
Contact Sheet	

Cancel OK

There are six metadata groups: EXIF, IPTC, Aperture, Audio/Video, Photo Usage, and Custom Fields. To see all the groups, click the triangle next to each group name to collapse the list or scroll down through the open lists.

Metadata Fields
► EXIF
► IPTC
► Aperture
► Audio/Video
► Photo Usage
► Custom Fields

> You can rearrange the names of the Metadata views (left column) by clicking and dragging them. The order of this list controls the order these views are shown in the pop-up menu in the Metadata panel.

- **Edit a metadata view:** Click the one you want to change in the left column; then check or uncheck boxes to change what that view will show.

- **Create a new metadata view:** Click the gear icon in the bottom-left corner of the window; then choose New View from the pop-up menu. When a new view appears in the left column, give it a name. Then check the boxes for the Metadata fields that you want displayed for this view.

Custom metadata fields

Custom fields are metadata options that allow you to create your own metadata fields. For example, say I want to keep track of which of my photos I have sold as prints. I could create a custom field named Print Sold. Then whenever I sell a print, I would enter **Yes** in the Print Sold field for that photo. Later, I could search for photos that have Yes in the Print Sold field to quickly see all the photos I've sold. Take advantage of the Custom Metadata

Fields when there's some type of information you want to enter about your photos that doesn't fit into the available fields.

Custom fields are created through the Metadata Views window. To create one, click the gear icon and choose Manage Custom Fields from the pop-up menu. This brings up the Custom Metadata Fields box. Click the plus sign to add a custom field; then give it a name. The minus symbol deletes the selected custom field.

The Metadata view's Action menu (gear icon) also has options for duplicating and deleting Metadata views.

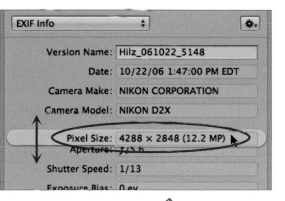

Earlier in this chapter there's a screen shot of the six groups in the Metadata Fields column. The last one is custom fields, and that's where any fields you create will show up. You can add custom fields to your Metadata views just like any other metadata field.

In the Metadata panel, you can change the order of the fields displayed for the selected Metadata view. Simply drag and drop the fields to rearrange them.

So far, we've looked at different ways to view metadata. Now we'll turn our attention to entering metadata, including using presets to automate the work.

With so many IPTC fields, there is a ton of information you *could* enter for each photo. That may seem overwhelming and make you wonder whether it's all really necessary. By no means do you have to fill in every field or even most of them. How much you enter depends on what information is important to you. Here are the fields I find the most useful to fill in:

- All contact information: Creator, Address, City, State/ Province, Postal Code, Country, Phone, Email, Website

- Location information (where the photo was taken): Location, City, State/Province, Country

- Copyright (© *Your Name*)

- Keywords

- Caption (if applicable)

Your contact information and the copyright notice are important to identify the photo as belonging to you. The rest of the information

is image specific and invaluable when searching for photos in your library.

Metadata presets

A lot of metadata you'll want to enter will apply to multiple photos. Instead of having to repeatedly enter the same information for numerous photos, take advantage of Aperture's metadata

presets to automate the process. They will make adding metadata much less time consuming. Consider your contact information, for example; that information is always the same no matter the photo. Also, if you have a group of photos taken at the same place, the location information will be the same for the whole group. Metadata presets are perfect for these situations.

Metadata presets are accessed through the Action menu (gear icon) in the Metadata panel (below the Camera Info section). Choose the Manage Presets option.

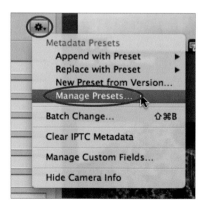

In the Metadata window that pops open, click the gear icon in the bottom left and choose New Preset.

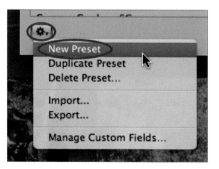

Give the preset a name.

k-Worthington Valley MD

US Botanic Garden

Enter information in the fields you want to use.

I use presets for two main purposes: adding my contact information and adding location information. I have created a preset that includes only my contact information. I use this one when I'm importing my photos. One of the importing options (see Chapter 1) is to use a metadata preset. I select the preset with my contact information, and it's all added right when the photo is imported.

My location presets include Location (if applicable), City, State/Province, and Country. After I import my photos, I select all the ones taken at the same location and apply a preset to them. The reason I don't add the location information upon import is that I may have photos from multiple locations on one memory card. You could put the contact and location info together in a preset.

One of the wonderful things about presets is you have to create them only once. After you take the time to create them, you just have to apply them. I now have more than 150 location presets. Sounds like a lot of work to create that many presets, but it was done over time. Each time I photographed at a new location I'd create a new preset. The next time I photographed at that location, the preset was right there waiting to be used.

GSMNP – Tremont
GSMNP – Roaring Fork
Huntley Meadows Park VA
Iwo Jima Memorial
Kenilworth Aquatic Gardens
Lake Anne (Reston VA)
Lake Namakagon (Cable WI)
Lake Namakagon – Paines Island (...
Lewis Ginter Botanical Garden, Ric...
Long Branch Nature Center VA
Longwood Gardens PA
Lorton VA
Lorton Prison
Magnolia Cemetery SC
Magnolia Gardens SC
Manassas National Battlefield Park VA
McKee-Beshers WMA
McLean VA

The Action menu (gear icon) in the Metadata Presets window also includes options for deleting and duplicating presets.

2

Go to the Metadata panel. Click the gear icon, choose Replace with Preset, and then choose the preset name from your list that pops up. That's it! With just a few clicks, you've added the metadata. The metadata in the preset will be applied to all the selected photos. The steps are the same whether you want to apply a preset to one photo or a hundred.

1

To apply one of the metadata presets you created takes only a couple of steps. Begin by selecting the photos you want to apply the preset to.

Append versus replace

You may have noticed the options Replace with Preset and Append with Preset in the Action menu. Choosing one of these options is an important decision if your photo already has metadata in the fields used by the preset. Append means it will add to whatever information is already there. For example, say my photo has Arlington listed in the Image Location field, but my preset has Springfield for the location. If I choose Replace, the Image Location will change to Springfield. If I choose Append, the location will read Arlington, Springfield. In most cases you'll want to replace any information that is already there, not append.

File naming presets

File naming presets are saved formats for renaming photos. These presets can be used when importing photos as well as when using the Batch Change feature

(Metadata menu). To edit and/or create file naming presets, go to Aperture>Presets>File Naming. There are a number of default presets that you can modify or delete depending on your needs.

File naming basics

- The Format box is the place where you build the filename with the naming pieces listed below it.

- To modify a preset, select the name and then edit the information in the Format box.

- To change a name, double-click the preset name.

- To delete a preset, select it and then click the minus button at the bottom.

To remove all the metadata you've added to a photo (IPTC info), click the gear icon in the Metadata panel and choose Clear IPTC Metadata.

When renaming my files, I use a file naming format that has three sections: my last name, the date the photo was taken, and a four-digit number—for example, Hilz_100713_5410.

Example: Hilz_100101_1

Format: Hilz_10 (Image Month) (Image Day) _ (Counter)

Creating a new preset

1. Click the plus symbol (this actually duplicates the selected preset); then change the preset name.

2. Delete whatever is in the Format box; then create your own filename. Under the Format box are "bubbles" with various naming elements. To build the filename, drag the bubbles you want to use to the Format box. To include text in addition to the bubbles, click in the Format box and begin typing.

One reason I chose this file naming format is that it guarantees

I won't end up with duplicate filenames. Here are the rest of the reasons behind it.

- Using my last name identifies the photo as mine (you could also use initials if you have a long last name).

- The date format of year/month/day keeps the photos in chronological order if I sort by filename. I typed in **10** for the year because I prefer a two-digit year. Aperture's Image Year bubble would add 2010.

- The four-digit counter keeps the name of each photo taken that day unique.

COUNTER VERSUS INDEX VERSUS SEQUENCE

The differences between the counter, index, and sequence options can be confusing. They all add some kind of a number count to your filename, but how they do this varies.

- **Index:** Adds 1, 2, 3, and so on. Always begins at 1.

- **Counter:** Similar to Index but with greater control. You choose what number to begin with; then the count goes up from there (100, 101, 102…). You also select the minimum number of digits (0001 versus 001 versus 01).

- **Sequence:** Indicates a count in reference to the total number of photos being named: 1 of 50, 2 of 50, 3 of 50 and so on.

Keywords

Keywords are literally words assigned to a photo. Keywords are usually used to describe the photo: the location, who or what is in it, what's happening. The reason they're so helpful is that you can later search for a keyword to find a photo. If you assign the key-word *bridge* to every photo with a bridge in it, then all you have to do is search for *bridge*, and you'll find all your bridge photos.

You can add as many keywords as you want, but using lots of keywords is not a necessity. Try to add at least a few keywords to each photo. When choosing them, let the key elements in the image guide you to the best words to use. Think of it this way: What words would you think of if you were trying to find the photo? Adding those terms may seem tedious at first, but when you get into the habit, it'll go much faster. I prefer to add keywords after I've decided which photos I'm keeping and which I'm deleting. Because keywords are somewhat specific to individual photos I don't want to spend my time keywording photos that I end up deleting.

There are a number of different places in Aperture where you can

Keywords are more likely to be nouns (*house, lake, woman, child, hat, mountain*) but can also be adjectives (*fast, calm, tranquil, colorful*). Keywords should be single words, unless they are formal names. A red barn would be keyworded as *red* and *barn*, not *red barn*. On the other hand, a photo of the Washington Monument would be given the keyword *Washington Monument* because it's a formal name.

add keywords. Some are more efficient than others, depending on whether you need to add a few keywords to a single image, or you want to work on photos from an entire shoot. We'll look at all the options.

Metadata panel

In the Metadata panel, you've probably seen the Keywords field as part of some Metadata views. Click the Keywords box, and you can type in keywords for the selected photo. Use a comma and a space to separate the keywords.

This method adds keywords to only one photo at a time, even if you have multiple photos selected. How do you know which photo the keywords will be added to? Look at the group of selected photos. One of them will have a thicker white border than the rest. It's the photo that gets the keywords.

Keywords HUD

The Keywords HUD is a floating window that lists all the keywords you've ever used in Aperture. To bring up the Keywords HUD, go to Window>Show Keywords HUD or press Shift-H. There are some keywords already included when you install Aperture.

In the Keywords HUD, you can search for keywords, as well as add, delete, and organize them. At the top of the HUD is a search box. Begin typing in a word, and the keyword list immediately updates with any matches to your search. You don't even have to type in a full word.

If I enter fa, the list will show only words that have fa somewhere in them. The fa character combination doesn't have to be at the beginning.

In the Keywords HUD, the keywords are always kept alphabetically organized.

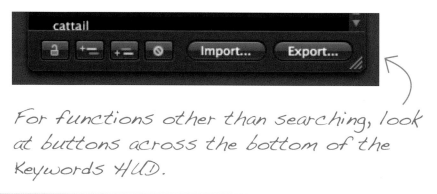

For functions other than searching, look at buttons across the bottom of the Keywords HUD.

Lock the HUD so no changes can be made, click again to unlock

Add a keyword

Add a sub keyword

Delete the selected keyword(s)

Import a keyword list (text file, must be tab-delimited in order to maintain any keyword hierarchy)

Export all keywords into a tab-delimited text file (maintains keyword hierarchy)

▼ Wedding
 Candids
 Ceremony
 ▶ Details
 Guests
 ▶ Portraiture
 ▶ Preparations
 Receiving line
 ▶ Reception
 Sequences
 ▶ Transportation
 Vows
 ▶ Wedding party

Ceremony
▼ Details
 Architectural
 Cake
 Clothes
 Fabrics
 Faces
 Flowers
 Hands
 Rings
 Table setting
Guests

click the arrow next to *Details* to see keywords for types of details likely to be found at a wedding.

To set up your own keyword hierarchy, start with the keyword that will be the topmost keyword (for example, *Wedding*). Select an existing keyword or add a new one. To add sub-keywords, click the Add a sub keyword button or drag existing keywords to the main keyword. If you move a keyword that's assigned to a photo, a warning will pop up telling you the keyword is being used. That's not a problem. Go ahead and click Move Keyword. The keyword will still be assigned to the photo(s); Aperture just updates where that keyword is located.

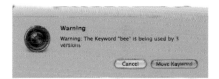

Creating a hierarchy for your keywords helps keep them organized. *Hierarchy* just means putting your keywords into groups. To see how a keyword hierarchy can be structured, look at the *Wedding* keyword that's included in the HUD by default. *Wedding* has an arrow

next to it, which tells you it's part of a keyword group. Click the arrow to expand the group.

Under *Wedding*, you'll see another list of keywords. Some of these keywords have triangles next to them, indicating they each hold a set of keywords. For instance,

To add a keyword to a photo using the Keywords HUD, click and drag the keyword from the HUD to the photo. When you drag the keyword, you'll see a green circle with a plus sign, which tells you a keyword will be added. If you have multiple photos selected, the keyword will be added to all of them. You can add multiple keywords at one time by selecting more than one in the Keywords HUD. To select multiple keywords, hold down the Command key when clicking the words in the HUD.

If you drag the top keyword in a hierarchy to a photo, such as Wedding, the Keywords HUD will add only that keyword; it will not add the other keywords grouped under Wedding.

I find the Keywords HUD most useful for organizing my keywords. I don't think the clicking and dragging required to add keywords is the fastest method unless there are a number of keywords near each other in the hierarchy. If you have lots of keywords, you spend your time searching the HUD or scrolling through the list to find the keyword you want.

Keyword controls

Keyword Controls is a convenient feature that offers a couple of ways to add keywords. To see the controls, go to Window>Show Keyword Controls (or press Shift-D to display and D to hide). A bar pops up across the bottom of the Aperture window. This

bar is filled with buttons, each of which has a keyword. Click a button to add that keyword to the selected photo. If multiple photos are selected, the keyword will be added to all of them.

These keyword buttons are custom sets of keywords, meaning you get to choose what keywords are used for the buttons. By choosing frequently used keywords, you can speed up the keywording process because all you have to do is point and click.

To the right of the buttons is a pop-up menu with the currently selected custom set. The default one is Photo Descriptors. This menu lists the custom sets. Select a different set, and you'll see the keyword buttons change.

| tdoor | Headshot | Group | Silhouette | Day | Add Keyword |
| se-up | Full body | Conceptual | Still life | Night | Photo Descriptors ⬍ |

To edit the keyword sets or create new ones, choose Edit Buttons from the pop-up menu.

In the Edit Button Sets window, you'll find the names of the sets on the left, the selected keywords in the middle, and your entire keyword library on the right. To make a new set, click the plus sign button in the bottom left and then name the set.

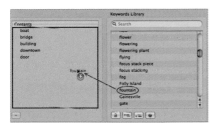

In the right column, find a keyword you want to use (the search box makes this procedure quick and easy). Drag the keyword to the center column. To delete a keyword from the Contents column, select it and then press the Delete key, or click the minus button at the bottom of the column. You can also rearrange the keywords by dragging and dropping. The order of the keywords controls the order of the buttons.

Need a keyword that's not in your keyword library? You can add keywords using the buttons at the bottom of the Keywords Library column.

MAX KEYWORDS PER SET

You can choose up to 20 keywords for each set. If you drag more than 20 keywords, the last word in the list will be replaced. For example, if the 20th word is *cloud* and then you add *mountain*, the last word will change from *cloud* to *mountain*. There is no warning this is happening, and if you can't see the bottom of the list, you won't know it's happening. So it's a good idea to keep track of how many words you've added.

The buttons are the first half of what you can do with the Keyword Controls. The other feature that makes it so useful is the Add Keyword box, which you'll find right above the name of the current keyword group.

Add keywords with three easy steps:

1. Click in the box.
2. Type a keyword.
3. Press the Return key.

Type in flow, and a list of all the keywords that begin with those letters pops up.

You can add multiple keywords. Just remember to press the Return key after each one. If you have multiple photos selected, the keyword will be added to all of them.

What makes this box even more useful is that as you begin typing, it engages an auto-search feature. A list of words (from your keyword library) that begin with the letters you've typed pops up.

Flowers
Flowers (Details)
Flowers (Preparations)
flow
flower
flowering
flowering plant

flow

Photo Descriptors

I typed bui, and building was auto-completed because it was the only keyword in my library that began with bui.

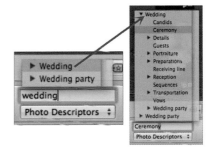

The more letters you type, the shorter the list becomes. When a list pops up, you can use the arrow keys to move through the list and then press Return to choose a keyword. If only one word in your keyword library matches what you've typed, that word will auto-complete in the keyword box.

If the same keyword is in different hierarchies (groups) in your keyword library, the name of the group it's part of will be shown in parentheses after the keyword. In the following example, *flowers* is a keyword on its own, but it's also within the keyword groups *Details* and *Preparations*.

If you see a keyword pop up with an arrow next to it, that means it contains a set of keywords. You can look in the set by clicking on the arrow or pressing the right arrow key to open the set. In the following screen shot, the arrow next to *Wedding* and *Wedding party* tells me they both contain other keywords. Opening the *Wedding* set, I can choose from the keywords in this group.

Overall, I find Keyword Controls to be the most useful for adding keywords to my photos. The ability to use the buttons for frequently added words as well as type in keywords myself (plus an auto-search) takes care of most of my keywording needs. I use the Metadata panel and the Keywords HUD in some cases, but not as often as I use the Keyword Controls.

Lift and stamp

The Lift and Stamp Tools can be used to copy metadata from one photo (lift) and add it to another photo (stamp). You can access the tools using buttons in the toolstrip or through the Metadata menu. Review Chapter 5 for detailed information about how to use these tools.

Metadata overlays

Metadata Overlays is the information you see below your photos (thumbnails or a single image). This feature is not connected to adding metadata, only viewing it. See Chapter 2 for all the details on how to set up Metadata Overlays.

Batch change

The Batch Change feature targets particular types of metadata. As the name suggests, it's good for changing the metadata for a lot of photos at once. Select the photos you want to adjust and then access Batch Change in the menus (Metadata>Batch Change) or by using the keyboard shortcut Shift-Command-B. There are three sections in the Batch Change window: Time Adjustment, Version Name Format, and Add Metadata From. If these options look familiar, it's likely that you also saw them in the Import Options. If you didn't use these options on import, or did but used the wrong settings, you can get everything straightened out here. You don't have to use all the options, just the ones you need.

Time zone

Was your camera set to the wrong time zone when you took the photo? Fix it here. Choose the time zone your camera was set to and then select the correct time zone for where you were photographing. Aperture will

adjust the time stamp for the photo accordingly.

Version name format

The Version Name is the name of the photo in the Aperture Library. This option will rename the selected photos in Aperture. Choose a file naming preset from the pop-up menu. See the "File naming presets" section earlier

in this chapter for how to create them. Check Apply to Master Files so that the photos on your computer have the same name as what you see in the Aperture Library.

Metadata presets

Earlier in this chapter, you learned all about metadata presets. You learned how to create them and how to apply them through the Metadata panel. Then how is choosing a preset here any different from doing so in the Metadata panel? The difference appears after you select the Metadata preset from the pop-up menu. You'll see the list of metadata in the preset, along with a checkbox next to each field. The checkboxes allow you to control which pieces of metadata are added to the selected photos. For any fields you don't want added, simply uncheck the box.

After choosing the metadata preset, decide whether you want to append or replace the existing metadata. If you're replacing incorrect metadata, then you'll

definitely want to choose Replace so the incorrect info is wiped out. To add to the existing metadata, select Append.

Searching

Now that you've gone through all the effort of adding metadata such as location information and keywords, what are you going to do with it? A key use for this information is when you're searching your library for a particular photo or photos. Anytime you're looking at your photos in the Browser mode (all thumbnails), there will be a search box in the top-right corner of the window. When you type something into that box, Aperture searches the photos that are currently displayed. If you have a project selected, then

Aperture will search the photos only in that project. If you want to search all the photos in your Aperture Library, go to the top of the Library panel and click Photos (in the group with Projects, Faces, Places). This will display thumbnails for every photo in your library, and when you search, it will search every single photo.

Whether you are searching one project or all your photos, the simplest way to search is to click the search box at the top of the Aperture window and type in what you're looking for (available in Browser and Split View modes). Aperture will search all the metadata for your search term. This means all the metadata you entered, such as location fields, contact information, keywords, captions, and filenames.

You can also choose from preset searches. Click the magnifying glass next to the search box to see searches related to ratings and labels.

A search is specific to the selected project. If you switch to a different project, there will be no search applied. Also important to know is that a search is not removed when you leave a project. If you search project A and then switch to project B, when you go back to project A, the search will still be applied. This can be a good thing if you still want access to those search results. On the other hand, if you don't remember you did a search, you might be wondering why you can't see all the photos.

After you search for something, the search terms will stay in the search box until you clear them. Clear the search by clicking the X at the end.

For more advanced search options, click the button to the left of the search box; it has a smaller magnifying glass on it. This brings up a floating window where you can customize your search as much as you want. The options here are similar to what you see for a smart album (see Chapter 3 for more about smart albums). You can use multiple criteria; plus there are many options and qualifiers for the criteria. The buttons at the bottom give you the option to turn the search into a smart album, or you can create an album that includes the photos displayed from the search.

Conclusion

As you can see, all this metadata is a big help for finding your photographs. Entering location and keyword information may be a hassle, but if you get in the habit of doing so, you'll reap the benefits when it's time to find a particular image. Let's review what you can do. The Metadata panel can be used to review technical data about your photographs or enter your own information in the IPTC fields. When you have metadata that you'll be using repeatedly (such as locations), save yourself some work and use metadata presets. Add keywords to each photo using the Metadata panel, the Keywords HUB, or the Keywords Controls. To find photos based on metadata, you can use the search box at the top of the Aperture window or create a smart album. Using these search features is the way to leverage all the information you've entered. It also keeps you from having to scroll through various projects and hundreds or even thousands of photos!

Chapter 7: Output: Exporting, Email, and Social Media

YOU'VE FINISHED EDITING your photos, they look great, and now you want to share them. There are a number of ways you can do this right from Aperture. Here and in the next two chapters, you'll learn all about Aperture's various export and output options. You can email your photos or share them on Facebook and Flickr. What about creating a showcase for your photos with a slideshow, web journal, or web gallery? You can even share them in printed form through books or prints. You might find the image adjustment process was just the beginning! This chapter focuses on exporting and emailing photos, plus uploading them to social media sites.

Exporting

Aperture's exporting options are found in the File menu. There are choices to export versions, masters, and metadata, as well as export photos, into a new Aperture library.

Export versions

Exporting versions is the export option you'll most often use (File>Export>Version). Think of exporting a photo as choosing Save as... for some use outside Aperture (such as a blog, website, or online printing). No matter the file format (RAW, JPEG, TIFF, PSD), exporting is the way to go when you want to use that photo for something else. You can choose the file type, size, resolution, color profile, and more for these copies. Creating various presets for exporting saves a lot of time and effort, as well as your having to remember which settings to use! With presets, it's

as easy to export one version as it is a hundred. When you choose Export>Version from the File menu, there are two keys things you must choose: where to save the file and which preset to use.

In the top half of the export versions window, you locate the folder in which you want to save the version(s). Directly below this section is the place where you choose an export preset. Click the Export Preset option to display a pop-up list of the presets. Aperture comes with default presets; plus you can create your own. To access the preset options (for editing, creating, deleting),

choose Edit from the bottom of the list. See the following section for details on creating image export presets.

The other two options in this window are Subfolder Format and Name Format. Subfolder Format allows you to save the exported versions in a subfolder within the folder chosen above. The pop-up menu gives you options for how you want to name the folder. Name Format is for renaming the exported versions. The pop-up menu offers naming formats. If you don't want the photos renamed, choose Current Version Name.

Image export presets

The presets for the Image Export can be accessed in a couple of ways. First, they can be accessed at any time by going to Aperture>Presets>Image Export. Second, if you're in the process of exporting a version, choose Edit from the Export Preset pop-up menu. There are a number of default presets that you can modify or delete depending on your needs.

Presets are listed on the left, and the settings for the selected preset are on the right. To edit a preset, select the preset name and then change the settings. To add and delete presets, use the plus and minus buttons at the bottom of the window. The plus button actually duplicates the selected preset, but you can then rename it and change the settings.

- **Image format:** Choose the file type that fits your needs. Use JPEGs whenever the photo will be used online or for email. You would use TIFFs or PSDs mostly when you take the file into Photoshop or Photoshop Elements to work on it. Check the box for Include Metadata.

- **Image quality:** The Image Quality slider will be accessible only if you chose JPEG; 8 is a good setting to use. None of the other file types have a quality setting.

- **Size to:** Choose how you want the photo resized. You can measure the resizing in pixels, inches, centimeters, or a percentage. To keep the size of vertical and horizontal photos the same, enter the same number in the Width and Height fields. Don't worry; this will not turn your photo into a square! What you're doing is setting the maximum length of the vertical and horizontal dimensions; this will make all the photos the same size.

- **DPI:** Stands for dots per inch and is also referred to as resolution. Use 130 for photos to be used online or for email. Use 300 for photos that will be printed or ones that you'll work on in another program (for example, Photoshop, Photoshop Elements).

- **Gamma adjust:** This setting increases the brightness of the exported photo. I don't use it because I've already made any necessary tonal adjustments to my photo using the Adjustments panel.

- **Color profile:** Pick the appropriate color profile for the purpose of your export. If the photo is to be used online, for email, or for digital projection, go with sRGB (its full name is sRGB IEC61966-2.1). If the photo will be printed, use sRGB or Adobe RBG 1998. If I'm printing the photo myself, I prefer Adobe RBG 1998. If someone else is doing the printing for you, check with the printing service to see which it recommends. Many online printing services will want you to use sRGB. Check the box for Black Point Compensation; this will fine-tune the black point of your photo based on the color profile selected.

- **Show watermark:** Check this box if you want to add a watermark to your exported photo. The Position setting controls where the watermark will be placed on the photo. I use Lower Right. Reducing the Opacity from 100% will fade the watermark into your photo. It'll still be visible but less obvious. You don't want the watermark to draw too much attention to itself. I find 50% Opacity is a good balance.

The challenge using this watermark feature is that you have to create an image file (such as a JPEG) that will be used for the watermark. You'll need to create the file in another program such as Photoshop or Photoshop Elements. Then click Choose Image and locate the file on your computer. You'll need to go through some trial and error to determine what size to make your watermark so it's not too big but not too small. What size to make it also depends on what size the image will be (the Size To setting). You'll likely need multiple watermarks for various size exports. That's a bit of a hassle, but after you've figured out the right size(s), you're all set and won't have to do it again. I don't use the Scale watermark option because I don't have control over how Aperture scales it.

Exporting masters

The Export Master feature creates a copy of your original (master) photo (File>Export>Master). In the Export Master window, you choose where to save the copies, and whether you want to use a subfolder, rename the photos, and include any metadata you've added.

Creating a copy does not remove the original photo from your Aperture library; everything in your library will stay the same. A copy of the photo is saved on your hard drive, but this copy is not part of your Aperture library. The purpose of exporting a master is to use a photo for something unrelated to Aperture. For instance, say you need to send your RAW file to someone. You don't want to send the original and have it disappear from the Aperture library. So you export the RAW file (the master) and send that copy of the original file.

Exporting metadata

Exporting metadata (File>Export>Metadata) saves a text file with the IPTC metadata that you've added to a photo (contact info, location, keywords, and so on). In the Export Metadata window, give the text file a name and choose where you want to save it.

In the text file, the information is arranged in a tab-delimited format, which means a tab separates each column of text. This makes it easy to import the text file into a spreadsheet or word processing table because all the information will line up neatly into columns.

Exporting a project, folder, or album

The option to export a project, folder, or album allows you to have the same photos in multiple Aperture libraries. All you have to do is select a project, folder, or album in the Library panel and then go to File>Export> _____ as New Library. All the photos in the selected project, folder, or album will be exported to the new library. All adjustments and metadata will be copied along with the photos. If you don't want to export all the photos in a project, use an album instead. Create an album with the photos you want to export and then export the album. The key point to understand is that when you use this export option, the photos will stay in your current library, and they will also be in the new library.

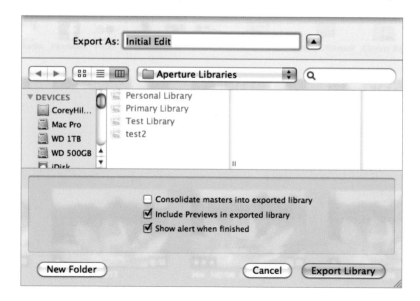

In the export window, you'll give the new library a name and choose where you want to save it. If the photos you are exporting are Referenced Files, you can have them be Managed Files in the new library by checking the Consolidate masters… option. Checking the option for Include Previews… copies over the current image previews, saving Aperture from having to generate them again in the new library.

Emailing photos

Aperture makes it convenient to share your photos by email. Begin by setting up a couple of preferences. Go to Preferences (Aperture>Preferences) and select the Export section. In the bottom half of the window, there are a couple of email-related options.

- **Email using:** Choose your email program, such as Apple's Mail application.

- **Email photo export preset:** The preset controls the size of the photos that will be attached to the email. These are the same presets discussed in the "Image export presets" section. To keep your attachments from being too large, send them as JPEGs with the height and width no larger than 1,000 pixels.

When you have your preferences set, it's a quick process: Select the photos you want to email and then go to File>Share>Email (or click the Email button in the toolbar). Aperture creates copies of the photos (based on the preset chosen), then opens your

email program, creates a new message, and adds the photos as attachments. All you have to do is choose whom you're sending the email to, add a subject and a message, and click Send.

Facebook and Flickr

Without leaving Aperture, you can upload photos to the online social networking sites Facebook and Flickr. If you don't have an account with these sites, first go to the Facebook or Flickr websites and sign up; then come back to Aperture. Next, select the photos you want to upload. Then click the Facebook or Flickr button in the toolbar. The publishing options for both Facebook and Flickr are similar.

| Email using: | Microsoft Entourage |
| Email Photo Export preset: | Web 1000px |

When you do this for the first time, you'll have to authorize Aperture to access your account. You'll be prompted to log in and then agree that Aperture can access the account. You have to do this only once, though.

For Facebook, you have the option to create a new album for the photos, add them to an existing album, or publish them to your Wall. Also, you can select who can view the photos.

For Flickr, you choose whether you want to create a new set for the photos, add them to an existing set, or add them to your Photostream. Then you can select who can view the photos and the photo size.

When you click Publish, Aperture will prepare the photos and then upload them. You'll see new items in the Library panel for your Flickr and Facebook albums. However, there may be multiple items listed for Facebook or Flickr even though you uploaded to

Would you like to publish 3 photos to Facebook?
The photos will be added to Corey Hilz's Facebook account.

Album: New Album

Album Name: Buildings

Photos Viewable By: Everyone

I certify that I have the right to distribute these photos and that they do not violate the terms.

Cancel Publish

Would you like to publish 3 photos to Flickr?
The photos will be added to Corey Hilz's Flickr account.

Set: New Set

Set Name: Buildings

Photos Viewable by: Anyone

Photo Size: Web Images

Cancel Publish

(or created) only one album. What you're seeing are all the albums for your account. When Aperture logs in to your account, it makes all your albums visible. This makes it possible to modify the contents of any album no matter whether you initially uploaded the photos from Aperture or not.

Select a Facebook or Flickr album to see the photos it contains. In the toolbar below the photos is a button labeled Facebook or Flickr. The button displays a pop-up menu from which you can access album settings or go directly to the album online.

FACEBOOK AND FLICKR
ALBUM TIPS

The albums you see in Aperture always mirror the actual album in your account. If you change something in Aperture, it will also be changed online and vice versa.

- If you delete a photo in Aperture from a Facebook or Flickr album, it will also delete that photo from your account.

- If you delete the entire album in Aperture, it will also be deleted from your account.

- If you add a photo to an album online, it will appear in Aperture when the album synchronizes. This is true even if the photo online is not in your Aperture library; Aperture will download the online version.

- If you delete a photo online, it will be removed from the Aperture album when it synchronizes.

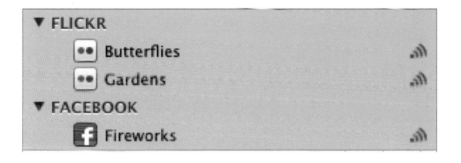

To add more photos to an album, drag them to the Facebook or Flickr album. Then click the publish button to the right of the album name. You can synchronize the Aperture and online versions of the album at any time by clicking the Publish button.

By default, Aperture automatically synchronizes albums. You can turn off the automatic synchronization in Preferences (Aperture>Preferences). Go to the Web tab, select the account, and uncheck the box labeled Automatically check for newly published albums.

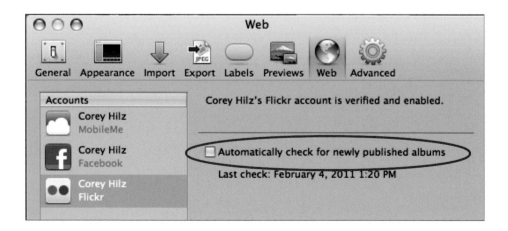

Share	▶	
Web Accounts	▶	**Disable All Accounts**
Relocate Masters for Project...		**Disable MobileMe – Corey Hilz**
Consolidate Masters for Project...		**Disable Flickr – Corey Hilz**
		Disable Facebook – Corey Hilz
Show in Project		
Show in Finder		**Edit Web Accounts...**
Locate Referenced Files...		

If you no longer want to manage your Facebook or Flickr albums through Aperture, go to File>Web Accounts and then choose the Disable option for the appropriate account. The account will disappear from the Library panel. This will not delete or otherwise affect your albums online. You're disabling only the connection between Aperture and the online account. If you change your mind, you can come back to the same menu option and choose Enable to turn on the account again.

Conclusion

After you set up the Export presets, email options, or access to your Facebook or Flickr accounts, all the hard work is done. Outputting your photos becomes as simple as selecting the images, choosing what you want to do with them, and then letting Aperture do all the work. Exporting? Choose the preset. Email? Click Email in the toolbar. Facebook or Flicker? Drag the photos to the album name. It's great when you can save yourself time and effort by taking advantage of Aperture's automation.

Chapter 8: Output: Slideshows, Web Pages, and Web Journals

EMAILING PHOTOS OR uploading them to social networking sites is a convenient way to share your images, but what about when you want to do more with them? What if you'd like to showcase your photos and make a true presentation out of them? For that, you can turn to slideshows, web pages, and web journals. Each of these features allows you to develop a complete package for sharing your photos. You can customize their appearance to produce the style you want. And even after you've put it all together, your layout will stay in Aperture so you can always revise it – just like being able to come back to your photos at any time and change previous adjustments. Aperture's flexibility and ease of use travel all the way through the workflow.

Basic slideshow

Setting up a basic slideshow is quick and easy:

1. Select the photos you want to include in the slideshow. If you select a project, folder, album, or smart album, the slideshow will include everything in it. If you don't want all the photos included, go ahead and select certain photos within the project, for instance.

2. After you've selected the photos, go to File>Play Slideshow.

3. In the Play Slideshow window, choose the slideshow preset you want to use. If you select a preset, wait a few seconds and you'll see a preview of the slideshow right there in the window. This is a convenient way to check out what various presets look like without having to run the slideshow. If you want to edit a preset, choose Edit from the bottom of the Slideshow Preset menu. Some of the presets automatically include

music; you can turn off this feature by editing the preset.

4. Click Start to begin the slideshow. The slideshow will run through all the photos and then return to the Aperture window. To pause the slideshow, press the spacebar; press it again to resume. If you want to control the pace of the slideshow, you can use the left and right arrow keys to advance the slideshow forward or backward. To exit the slideshow before it's done, press the Escape key.

Advanced slideshow

If you're looking for more control and customization over your slideshow, then you can create an advanced slideshow. You'll be able to go back and edit this slideshow because it will appear as an item in the Library panel. Begin by selecting the photos you want to include in the slideshow; then go to File>New>Slideshow.

A window pops up where you give the slideshow a name and choose a theme. Some of these themes are the same as those available for the basic slideshow. The most customizable themes are Classic and Ken Burns. In the slideshow window, you can see a preview of the selected theme. For the options illustrated in the section, I used the Classic theme. Also, make sure the box is checked to include the selected photos.

The slideshow appears as an item in the Library panel with the name you gave it. You can add photos to the slideshow at any time by dragging and dropping them on the slideshow name.

The title used for the basic slideshows is the name of the project or album where the photos are stored.

When the slideshow is selected, the Slideshow Editor is displayed. The Editor has three sections: thumbnails of the photos in the slideshow, options for the slideshow, and the appearance of the selected photo. The order of the thumbnails is the sequence the photos will be shown in. You can drag and drop the photos to change their order.

There are two groups of settings: Default Settings and Selected Slides. The Default Settings are ones that apply to the entire slideshow. The Selected Slides settings are for fine-tuning the appearance or behavior of individual images. As you work with the settings, be aware of whether you have Default Settings or Selected Slides selected. You don't want to change an individual slide when you mean to adjust the whole show.

Default settings

- **Aspect ratio:** This setting sets the "shape" of the slides; HDTV (16:9) is a good standard format unless you're designing a slideshow specifically for one of the other formats listed.

- **Repeat slideshow:** Check whether you want the slideshow to loop.

- **Loop audio:** If you're using an audio track and it is shorter than the slideshow, you can have it repeat.

- **Show title:** Title is the name of slideshow in the Library panel. It shows up in the center of the first slide. Using the buttons to the right, you can choose the formatting and color of the title. Alternatively, you could add a blank slide and then add text to create your own title slide. You'll see

details on how to do this later in the section.

- **Play slide for:** This setting controls how long each slide is shown.

- **Background:** This setting sets the background color for the photos.

- **Border:** If you want a border (outline) around each photo, you can also choose the border color.

- **Inset:** This setting creates a gap between the photo and the top and bottom of the slide.

- **Crop:** Fit in Frame means you see the whole photo. Fill Frame will crop and enlarge the photo so a portion of it fills the entire slide. Ken Burns Effect adds motion, zooming, and panning to the individual images.

- **Transition:** This setting controls the transition between

slides (a preview is shown in the box below).

- **Speed:** This setting controls how long the transition takes.

- **Text:** You can add text from one of the pop-up menu options. The text will appear on every slide. Using the buttons below, you can choose the formatting and color of the text.

Selected slides settings

When you click the Selected Slides button, the settings available are almost all options described in the "Default settings" section. However, these options allow you to customize individual slides (overriding the defaults). If you select multiple photos at once, the options chosen under Selected Slides will apply to all the selected photos. Photo Effect is the one option that isn't in Default Settings. It allows you to convert photos to a black-and-white, sepia, or antique appearance. This effect is only for the slideshow and doesn't change the photo elsewhere in your Aperture library.

Adding music

You can easily add a soundtrack to your slideshow. At the bottom of the Default Slides/Selected Slides section are two buttons for toggling between the Settings panel and the audio browser. Click the music note to switch to the audio browser.

The default display of the audio browser is Theme Music. Click Theme Music to show a pop-up menu with other sources of audio files, including your iTunes library.

To preview an audio track, select it and then press the play button at the bottom of the audio browser. When you find a track you want to use, drag it from the browser list to the thumbnail strip. You can have the music begin at the start of the slideshow, or you can have it start later.

To have the music start at the beginning, drag and drop the audio track to any gap between the photo thumbnails. The thumbnail background will turn green, and the name of the track will be above the thumbnails.

Adjust a photo at any time from within the Slideshow Editor. Double-click the thumbnail, which changes to viewer mode. Make your changes in the Adjustment panel; then double-click the image again and you're back to the Slideshow Editor.

If you want the music to begin with a particular photo, when you drag the track from the audio browser, drag it to the photo where you want it to begin. When you hover over a photo, you'll see a red line appear, indicating where the music will start. A green bar with the track name will appear under the thumbnails. You can always adjust where the track begins by dragging the green bar.

If the audio track is shorter than the length of the slideshow, you will see the green bar extend only partway through the thumbnails. You can have the track repeat with the Loop Audio option described previously in the "Default settings" section. You could also add another track from the audio browser.

To delete an audio track that's been added to the slideshow, click the track name in the thumbnail strip and then press the Delete key.

When dragging a photo from the audio browser, drag it directly it to the left or right to grab it. If you drag up or down, you'll end up selecting a series of tracks instead.

Adding slides

In addition to your photos, you may find it useful to add blank slides with or without text. You can use a blank slide with text at the beginning to create your own title slide. And you could do the same for an ending slide. To add these slides, go to the Action menu (gear icon) above the thumbnail strip on the left. There, you can choose to insert a blank slide with or without text.

The blank slide will show up in the thumbnail strip. You can drag it to where you want it in the slideshow. To add your own text to the slide, double-click where it says "Text Slide" on the slide. You can format the text using the Text options in the Selected Slides panel.

Watching a slideshow

Two playback buttons are available on the left above the thumbnail strip. The left one plays your slideshow from the beginning in full screen mode. The right button plays the slideshow within the Slideshow Editor and begins with the selected thumbnail. This second play button is convenient for previewing adjustments you've made to individual slides.

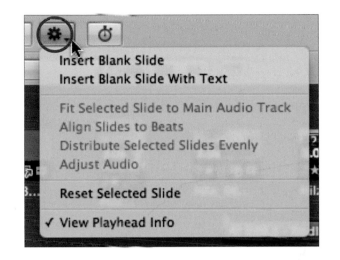

Exporting

Although you can play your slideshow within Aperture, you're also able to export the slideshow to use it outside Aperture. Click the Export button in the top right of the Slideshow Editor. In the Save dialog that pops up, choose a name for the slideshow file, where you want to save it, as well as the format (the Export for option). HD 1080p is the highest quality export format. After you make these selections, sit back and wait while Aperture takes cares of the exporting. This process could take awhile, depending on the length of the

slideshow, whether you added audio, and the speed of your computer.

Web page

Aperture's Web Page feature might be more appropriately named *web gallery* because that is specifically what you're creating. This type of gallery consists of one or more pages of thumbnails that show all the photos in the gallery. Each thumbnail is linked to a page that shows a larger version of the photo. To create a web gallery, begin by selecting the photos

you want to include. Then go to File>New>Web Page.

A window pops up where you give the gallery a name and choose a theme. The themes have different color schemes and variations in layout. For the examples shown here, I used the Stock Black theme. Also, make sure the box is checked to include the selected photos.

The gallery shows up as an item in the Library panel with the name you gave it. You can add photos to the gallery at any time by dragging and dropping them on the gallery name.

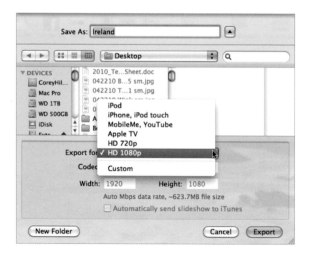

When the gallery is selected, the Webpage Editor is displayed. The Editor has three sections: thumbnails of the photos in the gallery (bottom), thumbnails of gallery pages (left), and the layout of the selected page (center).

The left column shows the thumbnail pages (the number of pages depends on how many photos there are) and the detail pages. Click a thumbnail or detail page in this column to display it in the large preview area to the right. There is a detail

page for each thumbnail photo. When a visitor clicks on a thumbnail in your gallery, he or she is taken to the detail page for that photo. You can navigate through the detail pages using the arrow buttons next to the detail pages section.

Adding text

In the top left of the gallery page, you can add a title and subtitle. Click the text placeholders ("Your site title," "Your site subtitle") and type in your own information.

Arranging photos

The arrangement of the gallery thumbnails is controlled by the order of the photos in the thumbnail strip. To rearrange photos, you can drag and drop them within the thumbnail strip. The gallery layout will immediately update. You can also change their order by dragging and dropping the thumbnails in the gallery layout (grid). When dragging and dropping within the gallery grid, you can't move a photo to a different page of thumbnails.

To remove a photo from the journal, select it and then press the Delete key.

Layout options

Directly below the gallery layout are options for arrangement and size of the photos. The options that are visible depend on whether you're viewing a thumbnail page or a detail page.

- **Columns and Rows:** Choose how many rows and columns you want for the thumbnail pages.

- **Fit images within:** To have the horizontal and vertical photos the same size, choose Square. The other options will make one larger than the other.

- **Width and Height:** Imagine each photo is in a box in the gallery layout; the last two numbers are the width and height of the box the photo fits in. The photos will change size as you adjust these numbers.

Columns: ◄ 3 ► Rows: ◄ 3 ► Fit images within: Square ⇕ ⬌ ◄ 250 ► [↕] ◄ 250 ►

Displaying metadata with photos

On the thumbnail and detail pages, you have the option to display metadata with the photos. The metadata comes from your metadata presets (see Chapter 6 for more information). To choose a preset, click the button with the "T," located above the gallery layout.

For the thumbnails, the metadata shows up below the photo; on the detail pages, the metadata is listed to the left. Having a lot of metadata below the thumbnails can look cluttered. Try using a preset that just has a small amount of info, or choose None from the list to show no metadata. In the detail view, a lot of information can fit neatly next to the photo. Each piece of metadata is on its own line. How much information you are able to display depends on what information you want to share with the people viewing your gallery.

Publishing

There are two ways to publish your gallery: manually loading the files onto your website or publishing through a MobileMe account. These options are available above the gallery layout.

Export Web Pages is for adding the gallery to your own website. In the Export window, you choose the name of the folder for the exported gallery, where you want to save it, and the quality settings for the gallery photos. I recommend choosing High Quality for both the thumbnail and detail images.

When you click Export, Aperture creates copies of the photos, resizes them, and writes the HTML code to produce the web pages. What you're left with is a folder that contains all the necessary files for the web gallery. All you need to do is upload the folder to your website, and visitors can access your gallery online.

Publishing through MobileMe requires less work, but you must be a subscriber to Apple's MobileMe service ($99/year). MobileMe offers more than web gallery hosting; you can find out more information about it on Apple's website. If you

do have a MobileMe account, you first should make sure you are signed in to the account. You can do this through the Web section of the Preferences (Aperture>Preferences). In the MobileMe publishing window, you

give the album a name and also choose the photo quality settings. I recommend High Quality for both the thumbnail and detail images. Click Publish, and Aperture prepares the files and uploads them to your MobileMe account.

When the publishing is complete, you can click View in Browser to view the gallery online. Whether you are using your own website or publishing through MobileMe, it's always a good idea to view your gallery online to make sure it looks as you expected.

Web journal

Web journals have a lot of similarities to galleries. Their key differences are the ability to add text, plus more flexibility with laying out the photos. I'll note which options or features are the same as for galleries; then you can find the details in the previous "Web page" section.

The web journals have a similar layout to thumbnail pages that link to a page with a larger version of the photo. To create a web journal, begin by selecting the photos you want to include. Then go to File>New>Web Journal.

A window pops up where you give the journal a name and choose a theme. The themes are the same as those seen for the galleries. For the examples shown here, I used the Stock Black theme. Also, make sure the box is checked to include the selected photos.

The journal shows up as an item in the Library panel with the name you gave it. You can add photos to the journal at any time by dragging and dropping them on the journal name.

When the journal is selected, the Webpage Editor is displayed. The Editor has three sections: thumbnails of the photos in the journal (bottom), thumbnails of the pages of the journal (left), and the layout of the selected page (center). However, compared to what you see when creating a gallery, the journal is a blank slate. The photos are not automatically added to a page.

Arranging photos

To begin designing your journal, drag a photo to the empty layout area. When you add a photo to the layout, it disappears from the thumbnail strip. When the thumbnail strip is empty, you've added all the photos you chose for the journal. There is another display option that allows you to see all the photos and use them more than once. Above the thumbnail strip on the right, there are two buttons; each has four rectangles on it. Click the left one to show all photos or the right one to see just the unused ones. When all photos are displayed, the photos you've placed in the layout will have a number on the thumbnail

telling you how many times it's been used.

Although adding photos is as easy as dragging and dropping, precisely where you "drop" the photo makes a big difference in the layout. When you drag a photo to the layout, you'll see a green plus sign next to your mouse pointer when you are over an area where you can drop it. You will also see either a horizontal or vertical green line. This line tells you where the photo will be placed. A vertical line means the photo will be added to the other photo(s) in that line. A horizontal line means it will be in a separate group above or below the existing photos. This may not seem an important distinction, but its significance will be apparent when we look at adding text.

If you hover your mouse pointer over a photo, you'll see an outline appear around the photos in that group. There's also a minus sign in the top-right corner of the group; you can click it to remove the group from the layout and send the photos back to the thumbnail strip.

If you drag a photo directly on top of an existing photo, it will replace that photo in the layout. You can have as many rows and/or groups as you want. The journal page will become longer to accommodate them.

Adding text

In the top left of the journal page, you can add a title and subtitle. Click the text placeholders ("Your site title," "Your site subtitle") and type in your own information.

Journals allow you to add extra text. Above the layout area is a button with a large "T" on it. Click this button to add a text box. The text box opens filled with Latin words. Just click in the box to replace it with your own text. The size of the text can be large or small. Hover your mouse pointer over the text box and look in the box's top-right corner. Click the T to switch text sizes. Click the minus sign to delete the text box.

To remove a photo from the gallery, select it and then press the Delete key.

Copyright notice

At the bottom of each page, you can automatically display a copyright notice. This is set up in the Export section of preferences (Aperture>Preferences). Near the bottom of the options, you'll see Web Copyright. Fill that in and it'll show up in your galleries. A standard copyright notice is © *Your Name*.

Layout options

Directly below the journal layout are options for arrangement and size of the photos. The options that are visible depend on whether you are viewing a thumbnail page or detail page. These are the same options as seen for galleries, except you don't choose a number of rows because you can have as many as you want.

Because you control which pages your photos are on, Aperture doesn't automatically add pages for thumbnails (it still makes a detail page for each photo used). To add or delete pages, use the plus and minus buttons below the detail page thumbnail.

The various text boxes and groups of photos can be moved around.

Hover over text/photos, and at the top center of the box, you'll see a small rectangle of dots. Click and drag this rectangle to move the box. Unfortunately, sometimes the rectangle can be hard to see because text or photos directly above it can cover it up.

Displaying metadata with photos

On the thumbnail and detail pages, you have the option to display metadata with the photos. To choose a preset, click the button with the *small* "T" on it above the journal layout. It functions the same as described for galleries.

Publishing

Web journals can also be published either manually through your website or through a MobileMe account. These options are available above the web journal layout.

Conclusion

At the beginning of the chapter, I mentioned the ability to customize the slideshow, web page, and web journal features. Now you know what I mean! There are many options to help you create the look (and sound) you want. All these output methods are presentations in a sense, so it's important for the whole package to look good. Besides all the outstanding options, the ability to come back a week, month, or year later and having the whole package right there in your Library are incredibly convenient. No need to start from scratch. You just pick up where you left off.

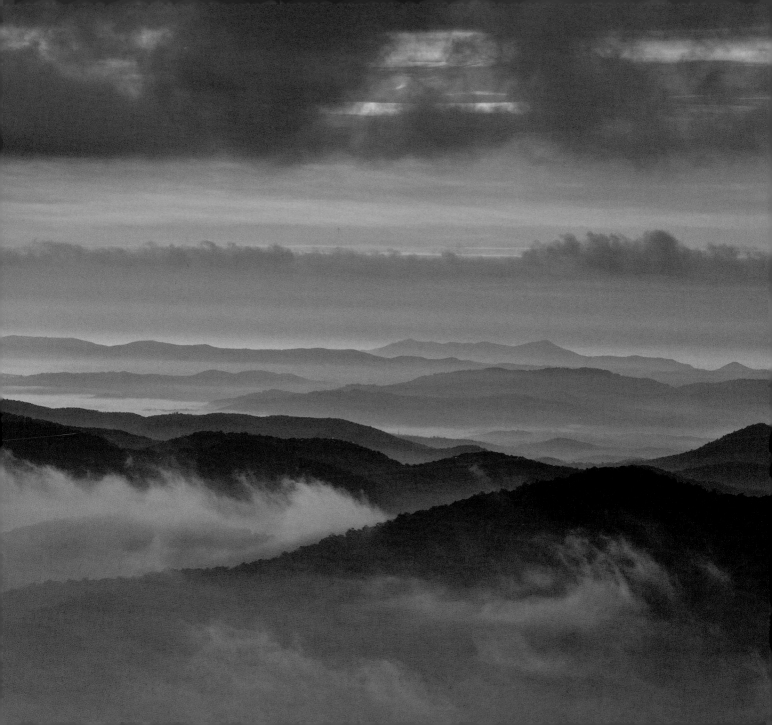

Chapter 9: Output: Printing Photos and Books

To WRAP UP the output options, we'll look at printing photos and creating books. The output methods discussed in the previous two chapters focused on electronic methods of sharing your photos. Now let's turn to showcasing your photos in a form that someone can hold in their hands. Having a gallery online or presenting a slideshow is a great way to share your work, but there's also something special about being able to hold the photos in your hand. Flipping through a book or admiring a print on the wall is simply a different experience from seeing images on a monitor. Whether it's for yourself or a gift for others, see what Aperture offers for your photos in the printed form.

Printing

After you've finished adjusting your photos, you can print them directly from Aperture. We'll look at two printing methods: printing a single photo and printing multiple photos as a contact sheet.

Single image

Select the photo you want to print; then go to File>Print Image. In the Print window, there are presets in the top left. Select the Standard preset. Below the presets are the printing options.

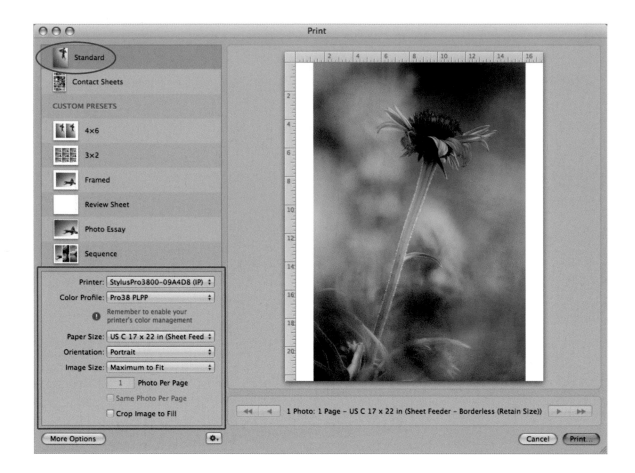

Standard printing options

- **Printer:** Choose the name of your printer.

- **Color profile:** If you have ICC profiles installed (printing profiles for specific printer/ paper combinations), you can choose the appropriate one from the pop-up list. If you don't want to use profiles, choose Printer Managed.

- **Paper size:** Select the size of the paper you're using.

- **Orientation:** Select which way the paper will go through the printer.

- **Image size:** Maximum to Fit will print the photo as large as possible on the paper. You can also choose from standard sizes as well as select Custom, which allows you to enter the print dimensions. If you check the box for Crop Image to Fill, Aperture will crop the photo to force it to fill the paper (for Maximum to Fit) or image size you selected.

Advanced printing options

For a more extensive set of printing options, click the More Options button below the settings. These additional options expand the settings seen in the basic set of options.

- **Layout:** You can set rows and columns to print multiple photos per page (same photo or different ones if you selected more than one photo for printing).
- **Margins:** Set your own page margins.
- **Rendering:** Here are more options if you are using a profile, plus the option to set the resolution.
- **Image adjustments:** A print may not come out looking just like it does on your monitor—for example, not as bright or not as saturated or lacking sharpness. Use these adjustments to fine-tune the appearance of the photo specifically for printing. This saves you from having to change your actual settings in the Adjustments panel.
- **Image options:** Add a border or watermark.
- **Metadata & page options:** Choose a metadata preset to have metadata printed on the page with the photo. Use the options to choose the position and formatting of the text.

{ After you've selected all the print settings, click the Print button to send the photo to the printer. }

Contact sheet

A contact sheet is a page that has multiple photos laid out in a grid pattern. It's often used to enable someone to quickly review a number of photos at once because each image is relatively small. Begin by selecting multiple photos; then go to File>Print Images.

In the Print window, select the Contact Sheets preset. You'll see the photos are laid out in a grid. Most of the printing options are the same as when you're preparing a single image. The new options are Metadata View and Rows and Columns.

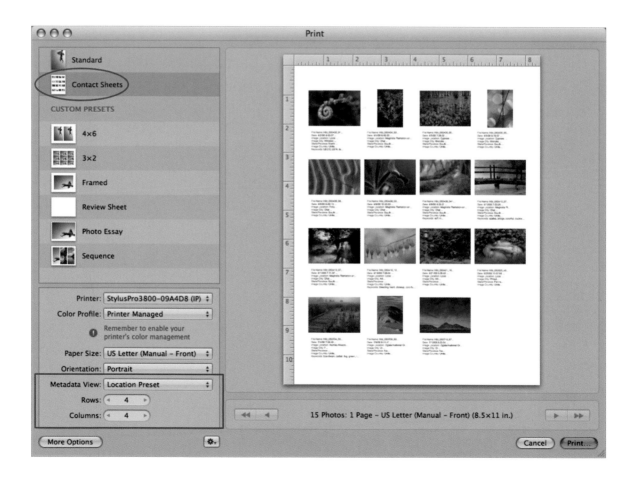

- **Metadata view:** Because contact sheets are often used as a way to review photos, information about the photos is frequently included. Choose a metadata preset, and information will be displayed under each image.
- **Rows and columns:** The number of rows and columns

determines the layout of your photos. Fewer rows and fewer columns means larger photos.

Click the More Options button to display the additional settings described in the previous section. When your layout is set, click the Print button. When using a

contact sheet, you may not need to actually print it out. Having it in an electronic format may make it easier to share it with others for review. If that's the case, click the PDF button in the Print dialog box and select Save as PDF. Choose the name and location and click Save, and you'll have your contact sheet as a PDF.

You can also order prints directly from Apple. Select the photos and then go to File>Order Prints. You'll need to sign in to your Apple account or create one. The dialog that appears then will walk you through choosing the prints and purchasing.

Books

Another way to share your photos in the printed form is through a book. Begin by selecting the photos you want to include in the book; then go to File>New>Book. In the window that pops up, give your book project a name and choose the book type (size) and a theme from the list. Also, make sure

the box is checked to include the selected photos. For the examples shown here, I used the Modern Lines theme. To see details about book sizes and cost, click the Options & Prices button at the bottom of the window. This will launch your browser and take you to a page on Apple's website.

After you click the Choose Theme button, the book will appear as an item in the Library panel and you'll be working in the Book Layout Editor. You can add photos to the book project at any time by dragging and dropping them on the book name in the Library panel.

The Book Layout Editor has three sections: thumbnails of the photos selected for the book, thumbnails of the book pages, and the layout of the selected page. The left column shows the page thumbnails. The layout and colors of the pages depend on the theme you chose. You can remove a photo at any time by selecting it in the thumbnail strip and pressing the Delete key.

In the book layout, there are photo boxes and text boxes. Photo boxes are gray, and text boxes are filled with Latin words that you replace with your own text. If you want to keep the book designing process as simple as possible, all you need to do is place the photos and add text.

The process for adding photos is as easy as dragging and dropping. Simply drag a photo from the thumbnail strip to a box in the layout. To change a photo already in the layout, drag another photo on top of it, and the new photo will replace it.

You'll notice there are various shapes and orientations for the photo boxes. Some of the shapes are more likely to fit the proportions of your photos than others. If you've cropped your photos, that also affects how well they fit in the boxes. When the shape of a box doesn't allow you to show the whole photo, it's nice to have some control over what part of the photo is shown.

Double-click the photo in the layout, and an Image Scale box will pop up below the photo.

Now click and drag the photo to move it around within the box. You can move the slider in the Image Scale box to enlarge the photo. You are able to enlarge a photo and then click and drag to position it using any photo box in your layout.

To add text,
find a box of
placeholder
Latin text,
double-click
it to highlight
the words, and
then type in
your own text.

The previous settings and options are the bare minimum you need to design a book. However, there are many ways to customize the layout. Here's an overview of some additional options.

Changing page layout

In the page thumbnail column, the selected page has a small black arrow next to it. Click this arrow to display a list of other page layouts to choose from.

Adding or deleting pages

At the bottom of the page thumbnail column are plus and minus buttons. The plus button will display a pop-up menu with options for adding/duplicating pages. The minus button will delete the selected page(s).

Edit content and Edit layout

Above the layout section, there is a button for Edit Content and another for Edit Layout. Edit Content lets you change what's in the layout boxes; Edit Layout allows you to change the boxes themselves. For instance, to remove a photo from a box, choose Edit Content, click on the photo box, and press the Delete key. The photo disappears, but the box remains. Do the same thing with Edit Layout selected, and the entire photo box will go away. By selecting Edit Layout, you can also rearrange your text and photo boxes by clicking and dragging. You're even able to resize the boxes: select a box and then click and drag one of the squares along the sides.

Adding more boxes

Although the template you chose already has boxes in the layout, you can add more. Perhaps the template includes a blank page and you want to add a photo box to it. First, click the Edit Layout button. Then click the button with a plus sign on it (next to Edit Layout) and choose the type of box you want to add. After you add the box, click and drag to position it on the page.

Format text

Select a text box; then click the button with the large T on it above the layout. The pop-up menu will show you the text formatting variations available for your theme.

Photo filters

Select a photo and then click the Photo Filter button above the layout. There are options for B&W and sepia conversions. Also, you can add a Wash, which is like putting a haze over the photo. This filter is useful if you want to add a text box on top of a photo; the wash fades out the photo, which helps the text stand out.

Changing background color

You can even customize the background color of individual pages. To change the background color for the selected page, go to the Background Color button above the layout.

Viewing the full spread

When you're planning a book layout, it can be helpful to see the full spread, which is the double page view you see when a book is open. A set of photos may look good together on a page, but you also should consider how they will look paired with the photos on the page next to it. Below the layout area, on the left, are two buttons that let you switch between full spread and single page.

Thumbnail photos

Two options control which photo thumbnails are shown. You have the option to see all the photos selected for the book or just the ones that have not been added to the book yet. Which photos you see is controlled by two buttons on the right above the photo thumbnails; each has four rectangles on it. Click the left one to show all photos or the right one to see just the unused ones.

If you have all the photos shown, Aperture puts a number label on the thumbnails that have been added to the book layout. The number on the photo tells you how many times it appears in the book. There is no number on the photos that haven't been used.

Ordering your book

After you've finished designing your book, you're ready to order copies of it. Click the Buy Book button above the layout, on the right. The window that pops up will walk you through the steps to order your book from Apple.

Conclusion

We've reached the end of the many output options available in Aperture. Enjoy the printed version of your photos, whether it's a print, a book, or both. Being able to hold the finished work in your hands is a rewarding experience. I think it can offer a greater sense of accomplishment than sharing electronic versions of your images. Also, you're not likely to share as many photos in the printed form as you do electronically. This gives a special distinction to the ones selected for printing; perhaps they're your best of the best. However you may be outputting your photos, enjoy the experience of sharing your photography with others.

Conclusion

TAKING ADVANTAGE OF Aperture's many features gives you a powerful tool to use in your digital workflow. You now know how to use Aperture for importing, exporting, and everything in between. Granted there are lots of steps to remember, each of which have their own options and settings, but if you commit to an efficient, streamlined workflow it will make your life easier down the road. Make sure you even do the not so fun stuff such as location metadata and keywords. You'll be glad you did when it comes time to find a photo a year after you shot it. Get the most out of Aperture's adjustment bricks, including the ability to selectively apply adjustments with the brush. It's wonderful because it's all non-destructive, giving you the flexibility revisit your photos in the future when you want to do some more fine-tuning. Enjoy all the ways you can share you images because after all the hard work you put into them, you deserve to be able to get them out there for others to see. And remember the point of all this is to require you to spend less time in front of the computer, and more time taking photos!

Index